FOR IONA

A DAVID & CHARLES BOOK

First published in the UK in 2000

ISBN 0 7153 0982 X

Art Editor: Alison Myer
Page Layout: Sarah Ramsey
Illustrator: Mark McConnell
Photographer: Ed Reeve
Compiled by: Helen Chislett

Printed and bound in Italy by LEGO SpA

for David & Charles
Brunel House, Newton Abbot, Devon

Linda Barker

Creative solutions to home decorating problems

Telegraph magazine

TradeSecrets

David & Charles

747

TradeSecrets

Contents

When I was first approached by the Saturday *Telegraph magazine* about the idea of writing a regular column of answers to readers' home décor questions, I was doubtful about the longevity of such a page. Just how many design problems are there to solve? Would anybody bother to write? With so many books and homes magazines on the market, was there a place for a design agony aunt? I needn't have worried. The questions came thick and fast – enough to fill several columns a week.

Another concern was that the subject matter might be limited to the more usual queries: whether certain colours could be used together; how to renovate old floorboards; tips on making a stencil. How wrong I was. Certainly old favourites came up – and naturally were included there as they are here – but so did related issues: how to use 'dead' spaces in a room; whether you could have a white sofa in a family home; how to make a bedhead; ideas for making use of old, white, linen sheets. The range was extraordinary, but made my job increasingly interesting.

One thing I enjoyed from the very beginning was the rapport the column gave me with the readers. I also found that the Q&A format is a symbiotic one:

the questions raised stimulated my own creativity and often stretched my design capabilities in the process. There were times when I found that by solving someone else's query, I had actually created a new concept that I longed to try for myself – and usually did. It became obvious that solving other people's problems can be very inspirational.

The deadline is a wonderful forcing ground for solutions, too – many of these answers were penned sitting on a train travelling from one *Changing Rooms* location to another. Naturally, I asked the opinions of my fellow designers, but in the end preferred to come up with the answers myself – a column is, after all, a very personal thing. *Trade Secrets* is the Linda Barker way of doing something, not necessarily the text book solution.

It has been fun flicking back through the questions to decide which ones to use in this book. For me, it has been like reading a diary – I associate certain problems with where I was at a particular time. It is fascinating, too, to see how so much information and so many ideas have built up breathtakingly quickly – *Trade Secrets* is barely two years old – so maybe this is only the first of many compilations. Ordering it has not always been easy, and often the subject matter overlaps from one

chapter to another, but I am confident that the ten chapter headings will point you in the right direction.

I hope you will find this book useful as a source of ideas, as well as a quick guide to some common problems. Judging by the response to the column, it seems that many of you enjoy reading tips like these whether you are planning to put them into practice or not. Certainly I know that home-decorating enthusiasts will find their fingers itching to try out some of the ideas as soon as possible.

One of the things that hearten me today is how many women now tackle the sort of repair and decoration tasks that once seemed to carry a 'men only' sign. Manufacturers, of course, must take some of the credit for that, as they have come up with increasingly user-friendly products. I like to think that programmes such as *Changing Rooms* have also shown how easy it really is to achieve some stunning transformations in the home.

As I said at the beginning, the Q&A format is a two-way process: the reader can mould the content just as much as the writer. And for my part, solving your problems is fun and stimulating, so don't be embarrassed to ask – just keep those questions rolling in. After all, if the answer you want isn't here, you know what to do. . . .

Few people are lucky enough to live in rooms with perfect proportions and generous dimensions. Nearly always there is something wrong: too-low ceilings, poky windows, ugly features or awkward corners. Don't despair. There is a solution to every spatial problem, although the answer might lie in treating it in an unexpected way.

Whether or not your particular problem appears on these pages, you should be able to glean what is important to consider when deciding how to use space effectively. It's all about cultivating the ability to see a blank canvas, rather than the existing room. The questions here touch a nerve with us all – how to keep privacy without losing light; how to use the alcove space at each side of a fireplace; whether to remove central lights completely from a room. Storage is also a key issue in this section, to keep your home from becoming an unruly mess.

Learning how to use space well is the first step towards becoming a confident decorator, so spend time considering the stage on which you are going to perform. Solve the problems of structure and space and you will be halfway to achieving the professional look you want to create.

Structure&Space

TOP HEAVY

Q I have a flat which has been fitted with mock-Tudor beams. What is worse is that there is an unsightly finish between each beam. What can I do to improve their appearance? I would prefer not to go to the expense of ripping out the beams.

The quickest solution is to paint the whole lot white, then staple shallow folds of muslin between the newly painted beams, allowing them to hang in a shallow drape between each one. Don't add anything to the rooms that will draw attention upwards. Fit downlighters wherever possible and use table lamps in preference to a ceiling light. Hang pictures as low as possible (at eye level) and be careful to keep colour, textured fabrics and accessories to the minimum.

CEILING SNAG

Q We are buying a property that has horrible false ceilings but they have been expensively and expertly done. Is there anything we can do to disguise them rather than having to pull them down?

If you really can't pull them down, the next best thing would be to introduce a great lighting system – after all, access above isn't going to be a problem. I would use tiny starlight halogen downlighters, on a dimmer switch of course, and a secondary circuit with a candelabra-type fitting. Paint the ceiling pale, if it isn't already, and keep pictures hung low so the eye doesn't travel upwards.

SQUARING UP

Q During the war, the ceilings of some of the rooms in my house were reinforced with a grid of 5cm (2in) wide slats. I assume this was in anticipation of possible bombing. The grid is made up of about 12 squares. Rather than getting rid of it (which would probably bring the whole ceiling down) I fancy making a feature out of it. Do you have any suggestions?

You should definitely make a feature out of the slats, perhaps by gilding them with Dutch metal leaf and acrylic gold size. If you have a wooden floor, you could paint it with a pattern that echoes the ceiling. If you think this would look too over the top, try painting a checkerboard design onto a table and positioning this to get the full effect of the repeating squares.

LOOKING ROUND

Q My house has two porthole-style windows – one in the sitting room and the other in the main bedroom. Can you suggest suitable types of curtain or blinds?

Whatever you do, don't hang anything that would conceal such an unusual feature. Your choice of covering needs to be sympathetic to the style of your room. For a modern look, sandblasted glass would be an elegant choice. Alternatively, you could use shutters which can be tailor-made by specialist shops, allowing light to filter through the slats.

CANNY CRANNIES

Q We are planning the conversion of our loft into a bedroom with a bathroom. Do you have any suggestions for how best to use the triangular spaces that will run along the lower half of all the walls? My aim is to create as much storage space as possible without encroaching too much upon the room.

Good planning is the key to any successful interior, especially in an attic space where there are so many odd angles and shapes. However, the triangular 'gaps' in attic conversions can offer tremendous potential for storage. I would design compartmentalized cube-style units that will fill all the available space. Once the carcasses of the cupboards are built, hang simple, flat doors that fit flush to the edges. (Leave a couple of the smaller cupboards without doors so that they can be used to display objects.) Fit push-release catches so that the scheme isn't dominated by handles, and paint everything, including the doors, in the same colour so that they 'disappear' into the rest of the scheme.

THE LIGHT TOUCH

Q What is your view on central lights, particularly in sitting rooms? I have just moved into a house where all the rooms have central light fittings and I am considering removing them. Is this rash?

Think carefully about the overall design of the room before you remove a light; the key to successful lighting is to have a number of options. That doesn't mean you have to spend a fortune to achieve perfection – it could be as simple as adding chunky pillar candles and fitting a dimmer switch to your existing lighting. If you have enough side lights and floor or table lamps, and feel you are able to do without the central light completely, remove the fitting. I would always remove a central hanging light if the ceiling is low, as a pendant lamp will draw attention to it. You could also fit low-voltage halogen lights using the existing circuit (you will need access from above the ceiling). These always look good, particularly if you fit a low-voltage dimmer switch and have directional beams so that you can highlight a feature on one or more of the walls. The only disadvantage is that this system of lighting is quite expensive – but it is money well spent.

Tip

Don't despair if you forget to wire for picture lights – you can install battery-operated ones. Although the range of styles is limited, a change of colour to complement or harmonize with your room scheme is easily effected with a coat of enamel paint, or, for a slicker look, you could spray the casings with a chrome finish. Three small lights mounted in a line on the wall could look particularly striking if the room is decorated in a contemporary style.

DOUBLING UP

Q I have recently moved into a small flat and don't have much storage space. I have a spare room, but often have people to stay. What should I do?

You need to build a platform on which you can put a mattress for visitors. It can be as high as you like, but you might need to fix a rail so that no one goes bump in the night. You should also give guests enough head-room to sit up in bed comfortably. Unless your DIY skills are advanced, enlist the help of a carpenter. The platform should stretch between two walls, not taking up more than half the room (make sure you can still open the doors!) You will need some timber posts to support the open edge. Keep a ladder close by for access. You can now use the space below for cupboards or other storage.

CUPBOARD LOVE

Q We have just moved house and would like to install some kind of wardrobe in the hallway. However, we don't want the hall cluttered up with a bulky piece of furniture. Have you any suggestions?

If your hall has a dead end, this is the perfect place to build a floor-to-ceiling cupboard that makes maximum use of the available room. By putting a mirror on the front of each door you will also create an illusion of space. If your hallway is fairly wide, building a cupboard that is quite a bit narrower will help balance the proportions. It is also a good idea to paint it the same colour as the walls to avoid an 'intrusion' into the hall space. If neither of these solutions fits the layout of your hall, then you may have space to fit a long seat or bench with cupboards underneath for boots and shoes.

SQUEEZE IN A STUDY

Q We don't have the space for a study but we do have some spare room on a landing. Could this be turned into an effective workplace?

If there is space for a large cupboard on your landing, then the answer is Yes. You will need a double power socket directly behind it, so ask an electrician to fit one. This will eliminate the need for ugly extension cables. You should fit a sliding shelf into the cupboard at the appropriate height for a desktop (the only customizing you will need to do). Now add a halogen light to flood the desk with crisp, clean light. Fix cork notice boards to the inside of the doors, and fill the shelves with stationery and files. A fold-away chair can be stored at the bottom of the cupboard, or simply use a chair from a nearby bedroom.

SPACE V. STORAGE

Q At either side of the chimney breast in my sitting room, there is an unused alcove. I have avoided putting up bookshelves or cupboards here as I want to keep a sense of space. However, I need somewhere to store and display china, objects and books. The rest of the room is painted in neutral colours, and I love the idea of using silver in some way. Any suggestions?

Like it or not, shelving and cupboards are your best option, but rather than using timber or MDF, you could consider Perspex. Use a thick sheet for each shelf, or combine some corrugated 'roofing' sheets with a thinner piece of plain Perspex on top for an ultra-cool look. Work out how many shelves you will need, allowing for the inclusion of a cupboard in the lower section of the alcove. Use mirror glass at the back of the alcove between the last two shelves, but mount it tilting forwards so that you can see into whatever is below. Small blocks placed on the side walls of the alcove will prevent the mirror from falling forwards. Below, at about waist height, fit a short, wall-mounted cupboard where the traditional base unit would be, but add frosted glass doors. In the gap between the floor and cupboard, fit mirrors on all three sides and base to reflect light, and to keep the feeling of space.

SHELF HELP

Q In my sitting room the two alcoves on either side of the chimney breast are filled from floor to ceiling with very basic pine shelves. Do you have any ideas for giving them a face-lift?

You can easily do this by adding a section of chunky timber to the front edge of each shelf to make it look as if it has been constructed from expensive, thickly cut timber. Attach lengths of 5 x 2.5cm (2 x 1in) wood to the underside of each shelf by drilling long screws through from above. To keep the surfaces tidy, countersink the screws and fill the holes. Disguise any joins by using a woodfiller and sander. If you want to give the shelves a quirky look, you could paint each one and the wall in between in a different colour. Hot reds, oranges and pinks would look very striking.

ON THE RAILS

Q The bedroom of my rented flat has no hanging space. Have you any suggestions for an inexpensive but stylish makeshift cupboard?

Why have a cupboard? All those things that require folding can be kept in storage pouches which can be hung from a rail. The least expensive rails are those used by removal firms – simple but sturdy rails on castors. Push one of these against a wall and suspend a banner in front of the clothes to hang from ceiling to floor. Screw cup hooks at least 1m (1yd) apart into the ceiling space (using the joists to create strong fixings) and a further two hooks into the floor directly below the ceiling hooks. (Drop a length of weighted string from the ceiling hook to get an accurate position for the floor hook.) Measure between the hooks and cut out a piece of canvas, allowing an extra 5cm (2in) all around for a double hem. Sew the hem, fit metal eyelets at each corner, and secure the canvas on the hooks. You could either decorate the canvas or leave it plain. To reach the clothes, simply unhook the canvas from the floor fixings.

Tip

In the absence of adequate bathroom storage, use chrome piping to make rails on which to hang items, using chrome wardrobe brackets for the fixings. (You will find all the materials at a hardware or DIY shop.) Screw the chrome rail along the entire length of your longest wall, at about waist height, joining the lengths of pipe with short pieces of wooden dowelling. Hang blunt-ended, S-shaped hooks from the rail, then make simple shoe bags from white waffle fabric or towelling, and use plaited lengths of white string to loop these over the hooks. Sew labels on the bags so that you can identify the contents.

FILLING THE CAVITY

Q How do I build a recessed display niche into an internal cavity wall?

Your first task is to find out what space is available inside the cavity wall. (Assuming you have a modern home, this will be determined by the width between the internal timber uprights.) Use a drill to explore the wall at the point where you would like the recessed box: resistance to the drill indicates timber. Once you know what space is behind the plasterboard, mark the size of the niche on the wall and square it up using a spirit level. Pass a jigsaw through one of the exploratory drill holes so that you can cut away the plasterboard. Then build a sturdy box using 6mm (¼in) MDF, glue and pins (check the dimensions against the gap in the wall). Fit the box in the space and secure it with filler. Don't panic if some of the filler bulges out round the edges – once it has dried, you will be able to trim the edges with a knife. Fix a plain moulding around the front edges to cover the join between box and wall, then fill and sand any other holes before repainting the entire wall.

PRIVATE VIEW

Q Our neighbour's new extension overlooks our bathroom, which has a large window that allows in a lot of light. We need to solve the privacy problem but without losing the light and airy feel.

I have shutters in my bathroom to deal with a similar problem, but a considerably cheaper option is to use sheets of frosted film to decorate the windows. Cut small squares into the film before fixing onto the glass, and leave a small, clear border around the edges of the window for a sleek, contemporary look.

MIND THE GAP

Q I recently moved into a house with a fitted kitchen from which the appliances had been removed. My fridge doesn't fit the space where the old one stood and there is an ugly 7.5cm (3in) gap on either side. Is there anything I can do to cover up the gap that will not look too out of place?

Move the fridge so that it is flush with the neighbouring unit and there is a 15cm (6in) gap on the other side. This will give you just enough space to fit a single-width bottle rack. You might be lucky enough to find a ready-made rack that will slot perfectly into the space, but I suspect you will have to make your own.

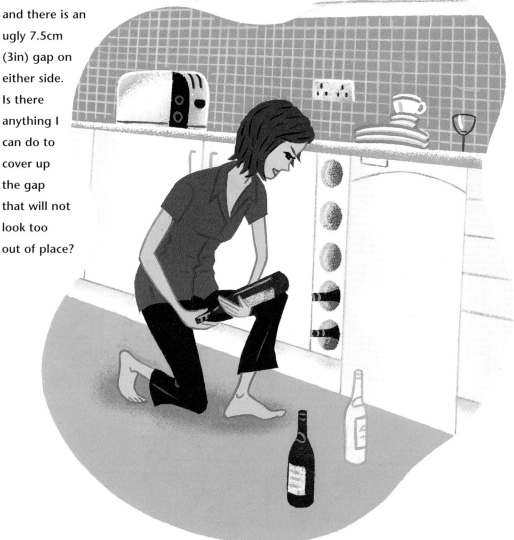

MAKING AN ENTRANCE

Q I have recently bought a flat in a Thirties mansion block. It has an old-fashioned sliding door that separates the kitchen from the sitting room. I would like to replace it with something contemporary.

My first instinct would be to tell you to remove the door completely and open up the space between the two rooms. But it is nice to be able to pull a door across the kitchen, particularly when it is messy. My advice is to revamp the door and then rehang it. It shouldn't be too difficult. If your door has glass panels, you could remove them to leave just the basic frame. If it is a solid door, then cut away the centre of it. Whichever method you choose, the frame of the door is what is important, and you should avoid damaging it. Next, find two prints (simple line drawings by Matisse, Warhol or Hockney would be great) that are large enough to fit into your door frame. I would have one poster facing the kitchen and the other facing the sitting room. Fix the images between two sheets of thin Perspex that have been cut to size. Secure the panel inside the door frame using glazing bars (just as you would for replacing a window). Finally, paint the frame of the door black before rehanging it on the gliders.

HALL OR NOTHING

Q We have just bought a small Victorian terrace house, and I want to knock down the wall between the hall and sitting room. Some people feel that a hall is essential – do you agree?

Given the choice, I would much rather have one large room than an average-size sitting room and a small, poky hall. However, others worry about the fact that not only do you step straight into the main living room, but also you bring a lot of cold air with you. This problem can be solved by leaving a small stretch of the dividing wall and hanging a curtain on a hinged arm over your front door to keep out draughts. Most people I know who have taken the plunge say that they have no regrets.

SHUTTER STYLE

Q I want to have some external louvre shutters fitted to two south-facing windows. Unfortunately, there is little space on either side of the window for them to fold back. Do you have any suggestions?

If there isn't enough space for full-size external shutters, it might be possible to fit shutters with a bi-fold hinge. These are really intended for internal use, but treated with an outdoor wood preservative they should withstand most weather conditions. However, I always think it's a shame to waste shutters on the outside. Fitting them inside not only looks great but is also cheaper, as you can make your own. Use 5 x 10cm (2 x 4in) battens to make up four frames to fit each window, two for each bi-fold shutter. (Each frame should be a quarter of the full width of the window). Use a mitre block to create strong mitred corners and fill the internal space with lightweight muslin or organza that can be stapled to the frame. Alternatively, you could use sheets of lightweight metal mesh. Cover the staples or sharp edges with thin wooden moulding, first mitred then glued and pinned in place. Next, using small hinges, join each pair of frames, ensuring that they will open out towards the room once fixed. Finally, secure the shutters to the sides of the window with strong hinges.

nfortunately, not all home styling is simply a matter of choosing a colour scheme or learning how to stencil. There is a far duller side to it, but one that is absolutely essential. It involves knowing what to do when things don't turn out as you planned. Moving into a new home and discovering gappy floorboards, damaged carpets or tatty tiles can dampen anyone's spirits and threaten holes in an already tight budget.

This section aims to guide you through such situations by telling you what can and cannot be done, with suggestions for the next best thing to do instead. Very often there is a simple remedy for what initially seems a major headache – but, as in all things, it is only easy once you know how. There are times, too, when some lateral thinking is called for, such as when a problem cannot be easily rectified. In these cases, it might be better to look for ways of camouflaging the problem area instead.

It is an unquestionable fact that knowledge generates confidence and ultimately makes you more creative, so knowing that most things can be put right if they go wrong means you are far more likely to try something new in the first place.

Practical Thinking

PATCH IT UP

Q A good-quality carpet is laid throughout our new house. However, there are stains which are so bad that not even professionals can remove them. Sadly, none of them is in a place where it can easily be hidden by a rug. Can you make any suggestions?

Your best option is to take up some clean carpet to patch the damaged areas. This is a job that is best left to professional carpet fitters; however, the cost of patching the stained areas and replacing the carpet you remove will only be a fraction of the cost of recarpeting the whole house.

TREADING THE BOARDS

Q We have decided to lift the carpet in our bedroom and sand the floor. Is there any way to seal the gaps between the floorboards effectively?

There are two methods of sealing the gaps without having to resort to lifting all the boards and re-laying them tightly together. Either use cork expansion strips (from any DIY store) or cut narrow wooden 'filets' from matching timber to plug the gaps. The method you use depends on how many gaps you need to fill and what finish you propose putting on the boards. For a varnished floor, I would opt for the wooden infill, fitting the tightest possible strips between the gaps as this will blend with the rest of the flooring. If there are fewer gaps in the boards, use cork strips and then cover the entire floor surface with a dark woodstain or paint.

ROOM WITH A VIEW

Q We have recently moved into a very draughty farmhouse in the middle of blustery moors. On a recent visit, my mother said that I would be mad to consider anything other than heavy interlined curtains, arguing that although they are expensive they are a lot cheaper than the double glazing we are thinking of having installed. What do you think about this?

If you can afford double glazing, then go for it. You won't have to spend your days feeling imprisoned by big, stuffy curtains that are sure to drive you to distraction. Consider those fabulous windy days when the light is perfect but the wind is howling. Imagine not being able to sit on the window-sill, looking out, because of a nasty cold draught rattling through the frames. Double-glazed windows with simple, tailored blinds and beautiful views of the moors is my idea of complete heaven.

> **Tip**
>
> If you are working on a tight budget and cannot afford to install double glazing throughout the house, you may choose to replace the windows in only those rooms where it really counts, such as the living room or kitchen. For bedrooms and hallways, interlined curtains are an excellent alternative. Interlining is inexpensive and easy to work with, although the results can look very bulky. Because of this, you should opt for simple heading styles and hang the curtains from a strong pole that has been well secured to the wall.

TRICK OF THE LIGHT

Q Our sitting/dining room is too dark. I am tempted to solve the problem by using lights and mirrors but am not sure which type. I don't want to see bulbs reflected in the mirrors. Have you any ideas?

Combine light from halogen downlighters with mirrors and candlelight. The halogen spots should be on a dimmer switch to give you various lighting options. The best thing about halogen downlighters (apart from the lovely clean glow) is that they are fitted flush to the ceiling and their light won't be reflected in any mirrors. Fix the candle sconces at eye height, making sure that their light is reflected. You can then enjoy good, subtle lighting that can be turned down and combined with candlelight when you are eating.

NO-WINDOW DRESSING

Q My new flat is almost perfect, except that the bathroom has no windows. I am about to completely redecorate it and put in new lighting. Do you have any suggestions as to how I might tackle it?

Lighting is an extremely important element in any room, so in places where there is no daylight you really do need help. Think first about the overhead lighting. In my opinion, halogen downlighters are a 'must-have' here because they produce a wonderfully pure, even light. Make sure they are on a switch located outside the bathroom so that you can fit a dimmer switch (it is illegal to fit one inside a bathroom). Now, add your 'task' lighting, such as lights over the mirror. In a bathroom with no natural light, you will also need a focus for the room that a window would normally provide. I would build a shallow cupboard against the longest wall (about the size of a small window) and glaze the two doors with patterned or frosted glass. Employ an electrician to install a small strip light inside the top of the cupboard, which should be wired to come on with the overhead lighting. You won't have a real window, but I think this solution is better than any fiddly *trompe l'oeil* effect – and a lot more practical when it comes to hiding your toothbrush.

BRIGHTEN UP

Q My flat is north facing and overshadowed by other buildings. Do you have any suggestions for how I can maximize light?

Keep the walls pale – a classic ivory would work well. Use a paint that has a sheen, such as vinyl silk, or, better still, paint a coat of high-gloss acrylic varnish over the walls once they are painted. This will reflect rather than absorb light. If there are alcoves, clad them from floor to ceiling with mirror tiles. Use halogen light fittings as these emit bright light that is more like daylight than conventional light bulbs. Finally, if the flooring in the room is dark, try covering it in pale rugs.

SHOWER CHIC

Q I have rearranged my bedroom to give me space to have a shower room. I am very keen to have a chic, contemporary-looking shower surround. What would you suggest?

Check the position of the water supply and drainage before you begin – installing a shower area away from the existing plumbing can be extremely expensive. If you don't want the restrictions of an enclosed shower cubicle then you will have to tile the floor and wall, remembering that the floor will need to slope gently towards the plug so that water can drain away. You will need a carpenter and a tiler who will fit a waterproof membrane between the tiles and the floor. Then you can build a wall made of glass bricks, perhaps in a curve to create a dynamic shape. Before work starts, it is important to ensure that the shower head can be pointed away from the door opening.

TONGUE-AND-GROOVY

Q We have a fully tiled bathroom that desperately needs updating. The problem is that if I remove the tiles all the plaster will crumble away, and I really do not wish to be faced with the expense of a total replastering job. Any suggestions?

The cheapest and simplest option would be to prepare, paint and then varnish the tiles. Or you could simply tile over the existing tiles, which is much easier than removing the old ones first. However, in your case I recommend covering the entire area with a tongue-and-groove wall cladding. The first task is to fit horizontal wooden battens across the front of the tiles to hold the boards in place. To fix the framework firmly, drill through the tiles using a ceramic bit and then use a masonry bit to create holes in the plaster behind. Paint and varnish the boards before fixing them in place – the varnish needs to be applied on both sides to guard against warping. Drive panel pins into the groove of each board (but hidden by the tongue of the next) to fix your cladding to the battens, then paint with a second layer of varnish.

THE RIGHT SURROUNDINGS

Q Have you any suggestions for making an elegant but masculine surround for my bath?

Timber decking is one of my favourite building materials at the moment and I wouldn't hesitate to use it as a slatted bath surround. It isn't cheap, but because it is fully treated for the outdoors, it can certainly cope with bathroom conditions. A roll-top bath is perfect for a slatted decking finish as the timbers (positioned vertically) will fit neatly under the lip, and each slat can be secured to the floor against a hidden batten. I would suggest that the slats butt up to one another in this instance. On standard baths with side panels, simply replace the panels with planks laid either horizontally or vertically, with or without 1.25cm (½in) gaps between each one.

Tip

Bathroom cabinets are always far too small to hold the numerous toiletries, first aid and medical supplies required by the average household, and a miscellany of items on open shelving is not only unsightly but a tiresome chore to keep clean. It is far preferable – and cheaper – to have one large bathroom cabinet than two or three small ones, so why not customize a kitchen wall unit. They can be bought in a variety of sizes to suit all but the tiniest of bathrooms and, depending on the style of unit, the addition of 6mm (¼in) thick mirror cut to fit onto each door will satisfy the need for a bathroom mirror as well as create an illusion of space.

TRADITIONAL VALUES

Q What flooring can I use to brighten up my hallway and stairs that would also work with the original dark brown embossed wallpaper?

Tiles look great in a hall and are easy to clean – a quick wipe will always restore their good looks. There are lots of excellent floor tiles around, including encaustic ones which create a traditional look. Whichever tiles you opt for, find a durable carpet runner for the stairs, preferably fitted with metal stair rods. Polish the wood on the edge of the steps if it is in good condition, or use a hard-wearing paint that complements the runner.

STICKY SITUATION

Q I would like to remove some tiles that have been glued to the floorboards in my home. How do I remove glue that is stuck fast to the boards?

The best solution to the problem of removing stubborn bits of glue is to use a power sander and a lot of elbow grease. Hard work, I know, but it is the only reliable way to remove such stubborn substances. If the job seems too daunting to tackle with a hand-held electrical sander, hire an industrial floor sander for the day and enlist the help of a few friends.

COUNTRY LIFE

Q The floor and walls of our farmhouse kitchen get a lot of wear and tear from heavy boots, children running about, dogs and – I'm afraid to admit – the occasional sheep. I need something that is easy to clean and won't wear out in a year or two.

If you want the most hard-wearing flooring, it will have to be natural rather than synthetic. Real flagstones would be perfect and true to the farmhouse tradition. However, slate, limestone or traditional outdoor paving would also be extremely good options. For softness, just add a rug or two where bare feet need the most comfort, but always make sure these are machine washable. Then clad the walls from floor to dado height with tongue-and-groove panelling. Not only is it simple to install but it looks great, and provided it's painted and sealed with at least three coats of acrylic varnish, it's easy to wipe away the stains that any child, dog or sheep might leave behind.

SET ON CONCRETE

Q The floor of my utility room has been skimmed with concrete in preparation for ceramic tiles. However, the concrete has a good flat finish and I like its colour. Instead of tiling, could I seal the concrete and leave it as it is?

Concrete is a wonderful surface and, like you, I love its subtle grey colour. Clearly, many architects and interior designers feel the same as it is becoming increasingly popular. It can easily be sealed; however, it should be left untouched for at least two months so that it can 'cure'. (During this time chemical changes take place that bring out salts.) After two months, use a floor varnish to seal the surface.

CHARACTER STAIN

Q When I sanded my old pine floorboards, I tested some varnish on them. I was disappointed to find that the resulting patch was very yellow. How can I get a darker, more contemporary look?

A good water-based, walnut-coloured stain should darken the floor sufficiently. Dilute two parts stain with one part water and apply with a soft cloth, rubbing into the grain. Work quickly and methodically, being careful not to overlap. (Don't use a brush as this will leave brushmarks.) When it is dry, give the floor three coats of acrylic floor varnish. If you don't want your hands to match the floor, wear rubber gloves.

CORK WORK

Q My kitchen floor has been laid with honey-coloured cork tiles by the previous owner. It is not something I would have chosen, but I think it would be an extravagance to replace them. I have heard much about painting floors and I was wondering if it might be possible to paint a cork-tiled floor effectively?

Painting cork tiles is as easy as painting any other floor but first you need to prepare the tiles so that they will take the paint. It is likely that your cork tiles have already been varnished, so this will need removing. A domestic power sander should be sufficient to do this, but it will still be hard work and you will need a lot of elbow grease. Don't be tempted to use an industrial sander as it will tear the cork to shreds. Once sanded, the porous surface can then be stained, colourwashed, stencilled or painted with whatever you like. Use one colour or, for an interesting effect, a combination of colours. Finally, revarnish the floor to protect the surface.

Tip

Some carpets are better than others at shrugging off stains, so check the care label when buying a new one. Remember, fashionable sisal, coir and jute, and anything else made of untreated natural fibres, are no match for pets without toilet training, and in my experience will always require professional cleaning whatever the stain. Before committing yourself, however, always make absolutely sure that the cleaning company knows how to clean this type of floor covering, as some have surprisingly little idea of how to proceed and will scrub away, destroying the weave.

BATHING BEAUTY

Q We have bought a house in which every room is carpeted wall to wall, including the bathroom. Do you think this is practical? If not, what do you consider to be the best material for a bathroom floor?

I have never been very keen on carpets in bathrooms, and if you can afford to replace yours I would do so at the first opportunity. I am a great natural-floor lover, and if I could afford it, every floor in my house would be covered in limestone. I also love wood, but this isn't the best surface for a bathroom floor. Tiles are the obvious solution for most people. Vinyl or lino tiles are available in all colours and finishes, and are easily fitted. Mosaic tiles are glorious, and can incorporate patterns and pictures. However, they are not cheap. Think of them as an investment.

> **Tip**
>
> For brightly coloured mosaic tiles, contact your nearest swimming-pool supplier who might be prepared to order tiles for you. Remember, though, that the brightest colours, which are always made from glass, are best used sparingly among plainer colours.

TIRED TILES

Q I want to revamp my kitchen on a very tight budget. It has some horrible tiles, decorated with garish poppies, that I can't afford to replace. Is it possible to paint or spray them without getting amateurish results?

Don't get me wrong – I'm no great fan of poppies stamped all over tiles – but kitchen surfaces have to take an inordinate amount of punishment and nothing beats the heavy-duty wear and tear of a hard, glazed, wipeable surface. What I would suggest is that before you resort to painting over your poppies, consider the practicalities: to have any chance of achieving a lasting paint finish you are going to need specialist tile primer, a topcoat and then a professional sealant. Now compare that with the cost of simply tiling over the poppies with a standard pack of plain white tiles, a pot of tile adhesive, grout and a pack of tile spacers. You'll realize that painting tiles is not as economical as you thought.

FOOT LOOSE

Q My lovely roll-top bath has no feet but I can't find suitable replacements for it. Any suggestions?

A stylish solution would be to rest the bath on two chunky lengths of timber, each about 20cm (8in) wide and 30cm (12in) high, long enough to run the width of the bath. Make a cardboard template of the underside of each end of the bath where the feet would be. Place a template against each block to saw out the two shapes (you may need a hammer and chisel). The two profiles will probably differ due to the varying shape of the bath at plug and head-rest ends. You'll be surprised how good natural, pale timber blocks can look against a gleaming white enamel bath.

SEE THE LIGHT

Q My sitting room is south facing and gets a lot of direct sunlight. As I have some nice old furniture and paintings, I wondered if there was a simple way to screen off the window so that nothing becomes damaged by the sun. Is a screen a good idea, or should I have a blind of some sort?

If I were in your position, I would be tempted to move the furniture and paintings to another part of the house and make the most of all that wonderful sunlight. You could decorate the room to give it a light, summery feel. Put down a light-coloured floor (limestone would be perfect, if you can afford it), upholster sofas and chairs in cream fabric, and perhaps cover them with a fake polar bear throw. But if you don't have room for the furniture elsewhere and the antiques have to stay, then you could make blinds from a light-reflective fabric – one that has a powdered aluminium backing that reflects both heat and light out of the room. Sew the cloth into crisp Roman blinds and relax in the knowledge that the bad UV rays can't get in.

GLASS CLASS

Q I have a rectangular skylight in my hallway, but the glass on the outside is almost impossible to clean. What could I do to the inside of the glass to make it look cleaner, without losing too much light?

A simple approach to your problem would be to fix a panel of semi-transparent fabric against the window frame. Cut a piece of cotton muslin to the same size as the window, adding 2.5cm (1in) to the longer sides (for hems) and 7.5cm (3in) to the two shorter sides to make deeper hems with channels wide enough for dowelling rods. Sew squares of transparent fabric onto the muslin – say, three squares for a small window, five for a larger one – and cut away the muslin that lies behind these squares to create an interesting pattern as the light filters through. Four cup hooks screwed into the window frame and lined up with the dowelling rods will hold it in place.

SIMPLE STORAGE

Q I want to build some inexpensive cupboards in an alcove and have thought of creating a fitted version of the fabric cupboards that are so fashionable at the moment. How do you suggest I go about this?

Trying to create a fitted version of the fabric cupboards in the shops would involve a lot of fiddly sewing. The most straightforward option is to hang a self-supporting rail between the two outer corners of the alcove and make a simple curtain in a fabric of your choice. Next, hang a clothes rail between the two inner sides of the alcove. Leave enough room for storage boxes and shoe racks at the bottom of the cupboard. If there is lots of room, you could also buy hanging compartments for jerseys.

These are the core decorating questions; the ones that go straight to the heart of a scheme. Not surprisingly, many of them tackle the question of colour: Will white look too cold? Can a black-painted room work? How do you choose shades that will complement an existing red carpet? Others are searching for advice on how to achieve a certain style – art deco, or maybe a Fifties look.

Also included are those questions that bridge the gap between aesthetics and function. Colour not only lifts the spirits, but it can also be used to solve such problem areas as a too-small room or an awkwardly shaped loft conversion. Above all, it can transform the dullest of rooms into one that vibrates with excitement. There is advice, too, on looking at your home as a whole, rather than becoming too focused on individual rooms. Cohesion is essential so that your nerves don't jangle as you walk around.

Perhaps the most important message here is to be bolder than at first you intended. Putting together a successful scheme relies on using colour and pattern with confidence. Putting together a stunning scheme means following your ideas through, right down to the tiniest detail.

DecoratingDecisions

BLACK MOOD

Q My husband plans to use the spare room as a study. He has seen a picture of a black-painted room and is keen to copy it. I can't talk him out of it. Do you have any advice on this?

Don't despair. Black rooms can look fantastic, though if the walls are less than perfect they will show every blemish. Think about lining uneven walls with black cotton drill or black wool serge, which will add texture. Secure timber battens around the walls and stretch fabric over them, as you would an artist's canvas. Alternatively, you could persuade your husband to go for a more subtle aubergine or dark chocolate paint, both of which work beautifully in small spaces. Whatever you decide upon, lighting is going to be a problem – create plenty of clean lighting with low-voltage halogen lights.

YELLOW FEVER

Q I want to paint our poky study a vibrant oriental-style yellow. I found a colour that I thought was suitable. However, when I painted a patch on the wall, it seemed too green. Can you suggest a yellow that would look right in the room?

Yellow is a very tricky colour to get right. The only answer to your problem is to go back to the paint shop and buy sample pots of each of your favourite yellow paints. Paint three 50cm (18in) square samples next to one another on each of the four walls. Look at them in the morning, midday, late afternoon and in the evening with lights on. This is the only way you will be able to choose a colour that suits the room.

COLOUR CONUNDRUM

Q We have a very gloomy hallway that we are keen to brighten up. I have considered painting it white but I think that might be too clinical. My wife won't allow pale blue, and we have banned magnolia from ever making an appearance in our house. Bright yellow hallways now seem to be rather a cliché. Do you have any suggestions?

If you both like bright yellow, does it matter that it's been seen before? Enjoy the colour for your own reasons – because it reminds you of a Tuscan sunflower field, or even a Premier League football strip. If yellow still isn't for you, try collecting your favourite bits and pieces from around the house and spreading them out to see if one particular colour stands out. The answer might well lie in a baby-blue T-shirt, the lavender soap you got for Christmas, or the washed-out denim jeans that always look so good.

Tip

MDF has a wonderful mellow colour and can be very attractive left in its raw state. Seal it with thinned PVA adhesive which, although initially white, will go clear after an hour or so, or use any water-based floor varnish as this will provide a tougher finish.

ATTIC ANTICS

Q I have converted my attic into a bedroom and study for my teenage son. Like most attic conversions, it has pitched ceilings and two triangular-shaped alcoves. Because the room is such an unconventional shape, I am flummoxed by the prospect of choosing paint colours. How should I go about it?

I would let the architecture of the space define your painting boundaries. Areas of wall inside an alcove should be painted in a darker, cooler tone and the main walls in a much paler tone of the same colour. Using two tones in this way emphasizes the construction of the room by tricking your eye into believing that the darker areas are further away and the lighter areas are closer. The paler colour will also be a good foil to natural light and will make the room seem larger. A soft green would be perfect in this situation, as it creates a serene atmosphere.

MASTER OF ILLUSION

Q We have just moved to a cottage in the Lake District. Unfortunately, my son's bedroom is really very small. How I can make it seem bigger?

The most important thing to do is paint the ceiling in a pale colour – this will instantly increase the sense of space in a room by reflecting more light into it. However, there are plenty of other good tricks. These include painting a broad horizontal band all the way round the room to make it seem wider, or vertical stripes to give the impression of height. Choose cool colours, such as pale Scandinavian-style blues and greens (both for the walls and the floors), which will make the room seem larger. You can also exaggerate the sense of space by graduating the colour from dark at the base of the walls to light as it gets closer to the ceiling. Alternatively, use a satin varnish over the pale paintwork, as this will reflect both natural and artificial light. To prevent the room becoming 'cold', try using warmer tones of the same colours for all the soft furnishings.

> **Tip**
> Awkward spaces may seem like a chore when decorating, but in fact they make features that add character to a room. Learn to love your cranky spaces and make something of them, rather than trying to camouflage them and pretend they don't exist.

TONE AND HARMONY

Q I live in a house that has four bedrooms, two reception rooms and a kitchen-cum-breakfast room. I would like to paint each room in a different colour, but this still leaves an enormous hallway, which you can see from every room. I like pale oranges, yellows, buff, creams, green and lilac. How can I combine so many different colours?

It is possible to use different colours and still achieve harmony. When you look at a paint chart, choose colours with similar tonal values. This has nothing to do with their colour, but depends on their degree of opacity, and the amount of light they reflect. A simple way to choose your palette is simply to screw your eyes up while looking at the colour chart – colours with different tonal values seem to jar, while tonally similar colours almost melt together. Happy squinting.

SUMMER BREEZE

Q I am planning to paint my bedroom but I cannot decide on a colour. I want a summery feel. Can you suggest some colours, and what can I do to transform the mahogany furniture?

First, get rid of everything in the room, even pull the flooring up if you are changing that, too. (I would go for something with a neutral colour on the floor, such as seagrass, coir or sisal.) Keep the colour of the walls, bedlinen and curtains (or blinds) neutral, too. Try colours such as taupe, cream, beige and off-white. Restrict vibrant colour to the dominant elements, such as the bed frame and furniture. Sand, prime and then paint the furniture. A warm cobalt blue would be perfect, but the colour is up to you: make sure that you are led by your own tastes rather than fashion.

UNIFIED APPROACH

Q I am about to move to a compact, west-facing retirement flat, with a square living room, a long, narrow bedroom and a narrow hallway. Can you suggest a colour scheme that will help to make the flat look bigger and more welcoming?

I would choose colours that unify the space rather than split it up. This doesn't mean that you should necessarily use the same colour throughout the flat. Instead, use colours that subtly contrast with one another. In the hallway, I would use the darkest colour, such as a greyish olive, on the longest wall. You could then paint the other walls and ceilings in a soft dove grey. Fix a large mirror on the wall so that it reflects any natural or artificial light. In the sitting room, use a greyish version of a duck-egg blue on three walls and paint the remaining wall cream. This will stop one colour becoming too dominant. Use a warmer colour to give the bedroom a softer look – a honey shade of ochre would be perfect. Throughout the flat choose accessories and fabrics with olive, grey and duck-egg blue so that you unify the effect. Paint the woodwork throughout with an off-white, eggshell-type paint. When possible, leave all the doors open so that you can see the colours interacting with one another.

Tip
If you have badly painted woodwork, don't try to disguise it with more paint. You can improve the finish with a power sander. Simply sand the woodwork back just far enough to get a smooth surface, and then use a good wood primer followed by a top coat of satin-finish paint.

COOL LOOK

Q The sitting room in my Eighties house needs to be overhauled. It has warm colours, heavy curtains and a horrid patterned carpet. What do you suggest?

It all rather depends on your budget. Bearing in mind the age of the house, the best look would be clean and modern. You need to let go of the warm tones and heavy curtains, and enjoy the freedom of a fresh palette; use cream, pale lilac or soft fern green. Fix shutters to the windows, if you can afford them, and blinds if you can't. Take the carpet to the tip and paint the floorboards, adding rugs if the floors need softening.

A FRESH START

Q What would you recommend to brighten up a dark and depressing sitting room with two sofas covered in a dark blue and crimson fabric? The bottom half of the walls is painted in a smoky pink colour, and the top half is covered in an ochre and pink wallpaper. It is a bachelor house, so frilliness is out.

Banish the pink walls and the wallpaper, and replace the carpet with a wooden floor. Paint the walls ivory, and hang four black-and-white prints in a square on the largest wall. Throw down a bright rug with a geometric pattern, and choose one colour from it for six large cushions – three on each sofa. Add uplighters and candles to maximize your lighting options.

KITCHEN FACELIFT

Q How would you transform a fitted kitchen that is basically sound apart from some very loose hinges and handles? We would like to have open-fronted china and food cupboards, and have even thought about replacing the doors under the sink with hanging silver chains.

First, remove the doors of the wall cupboards, fill the holes left by the hinges with wood filler and use them as open shelves. Next, tackle the loose hinges on the base units: it may be best to remove them, fill the holes and screw the hinges back on, either slightly below or above their original positions. Paint the units – you can buy special melamine primer – and then seal them with a clear acrylic varnish. Find one or two colours that work well together (I would be tempted to try a soft lime for the wall units and denim blue for the base ones) with a creamy limestone colour on the walls. A row of hanging chains is a great alternative to cupboard doors. Your local hardware store probably sells a wide range; try the beaded plug variety or a small-linked lighting one. Lengths should be hung close together so that the contents of the cupboard are hidden. Finally, replace existing handles with pewter-effect ones.

THE WHITE WAY

Q The window frames of our house need repainting. At the moment they are white but I would like to consider some alternatives. I always think that black is too funereal. From your experience, what works well?

Hand on heart, in my experience it's always best to go for white. I agree that black is too morbid, and the combination of black and white is too fiddly to be worth the effort. I have witnessed several very passable deep green alternatives, but even these wouldn't tempt me away from white. Let's face it, white window frames look great, especially with a colourful front door. Internally, it's a different story. If you have white walls, you could paint the woodwork black, as long as it's balanced by dark, heavy furniture and rugs. If you have mellow, natural tones and lots of light, you may prefer to complement these with a soft putty or mushroom colour. However, if you intend to use heavily polished furniture and deep-coloured fabrics, your woodwork could be a more gutsy, powerful colour such as burgundy, olive green or navy blue.

REFLECT ON THIS

Q We want to decorate our downstairs toilet. The easiest solution would be to paint it one colour, but I feel this might be a lost opportunity. Have you any suggestions for a simple, stylish way to decorate it?

Most downstairs loos are rather small, dark and gloomy affairs. One way to maximize light without hiring an electrician would be to use mirror tiles combined with two complementary paint colours in pale shades to make the room seem larger. Paint the walls in one of your chosen colours, then use the other colour to paint a 25cm (10in) deep band around the walls at shoulder height. Finally, use sticky pads to fix 15cm (6in) square mirror tiles to the centre of the stripe at intervals of around 15cm (6in).

WARM WHITES

Q I am trying to choose a colour for our bedroom, and am keen to paint the walls and woodwork white. My husband is worried that it will look too clinical and thinks that we should use off-white or cream. Do you have a view?

I think white can be a wonderful colour for a bedroom. Often it is overlooked because people think it creates a cold atmosphere. (This is due to the amount of blue that is mixed into most white paints.) The trick is to choose a white that is pure, clean and soft. There is a huge amount of white paint on the market, including soft, creamy whites. If your husband is worried about the room being too stark, you can always offset it with a rich, warm bedspread or throw.

CLEAN LIVING

Q My bathroom faces north and has green tiles. There are cork tiles on the floor and cork boxing around the bath. Can you suggest what I should do about the walls, floor and blinds?

The only answer is white – think of newly mown grass and white picket fencing. The combination of white and green is a bit obvious, but nevertheless works very well. Paint the walls and ceiling white, then sand and whitewash the cork tiles, sealing them with at least two coats of clear acrylic varnish to protect them. Add white blinds, thick white waffle towels and chrome accessories.

SOFTENING THE STARK

Q We have recently extended our kitchen with a modern conservatory. It is fitted with a stainless steel 'Island unit' and has a sandstone floor. We have furnished it with chrome chairs and a very smart table with a granite top. I was very proud of it until my sister-in-law told me she thinks it looks like a city restaurant. What can I do?

It sounds glorious to me, but certainly chic, modern kitchens can look rather stark and impersonal, particularly when new. Try bringing in some homely touches, such as collecting an assortment of tableware rather than one matching dinner service. Look out for antique serving bowls, plates and storage jars that are slightly worn (if possible, display these on open shelves) but try to restrict yourself to a few contemporary colours, such as grey, black, white or cream so that you don't create a chaotic jumble. If you have room, you could also introduce one or two pieces of antique country-style furniture so as to tone down the slick look.

AFRAID OF THE DARK?

Q I have redecorated my bedroom on a blue-and-white theme, and the curtains and duvet cover are made from the same blue-and-white check. I have painted the floor and the walls white and the woodwork blue. The only problem is that my pine blanket box and dressing-table now look rather out of place. What can I do to include them in the scheme?

First, strip away any protective varnish or wax layer on the pine furniture with varnish stripper or wax remover. Then – and I am asking you to be brave here – stain the entire prepared surface using a dark oak woodstain. Apply two coats if you are feeling gutsy enough because the colour I think you should be after is the deepest, darkest brown that almost verges on black. For perfection, add chrome drop handles with a black/bronze finish. A couple of dark brown accessories, cushions, lamps or storage boxes will help balance the scheme brilliantly.

DECKING ORDER

Q How can I brighten up my bathroom without changing the avocado suite and matching tiles – or spending too much?

Your best bet is timber decking. It is wonderful to look at and walk on – and with reasonable DIY skills or the services of a competent carpenter, you can have a highly desirable floor that won't cost the earth. Next, chip away at the tiles around the bath to reveal the timber frame that will have been constructed around it. Then, using more strips of the oily cedar decking, clad the walls. Wooden accessories and 'natural' coloured towels will complete the look.

BLUES BAND

Q I want to redecorate my sitting room in a combination of cream, beige and taupe. However, I am worried that my blue sofa will look out of place. Can you suggest an inexpensive makeover that won't involve the expense of making new covers?

Don't worry too much about the colour of your sofa. All you need to do is combine it with the right balance of neutrals and blues. First, look at the whole space rather than just part of it. Bring a little more blue into the room to reduce the sofa's dominance. Blue blinds made from a semi-transparent fabric, such as organza, would be light and fresh without being overpowering. Blue accessories on a coffee table, or perhaps a collection of blue vases on the mantelpiece, will all help achieve a balance between the different colours and will draw attention away from the sofa. Finally, large cushions in a combination of neutral tones and blues will help knit the look together.

IN THE RED

Q All the floors of my house are covered with deep red carpeting that dominates the colour scheme. As I can't justify ripping it out and replacing it, I plan to paint all the common areas of the house with the same colour. What colours would you use to balance it?

One blessing is that the whole house is covered in the same carpet – even if it isn't one that you would have chosen yourself. This will unify the rooms, and if you are clever it will be possible to integrate the colour into your own scheme. Although it might be tempting to lighten the overall effect with white paint, this will create a contrast that is too dramatic. Instead, choose colours such as parchment, wheat, oatmeal and limestone. Don't opt for anything paler than a deep cream, or darker than mushroom. You don't have to use just one colour – a combination would also work well. However, you should choose just one colour for the woodwork – again, avoid white and go for a greyish taupe.

GREEN MONSTERS

Q We have two good-quality, second-hand sofas. Sadly, they are upholstered in a rather unpleasant green fabric. We have painted the walls a lovely taupe and the carpet is oatmeal, but the green clashes horribly. How can I make the sofas work in the room without going to the expense of re-covering them?

It is a problem when common sense tells us one thing and our style conscience tells us another. Throws can help disguise the sofas but you will always see a little of the colour underneath, so I think the sofas have to go. For some reason, having a new loose cover made doesn't cost much less than a new sofa in the sales. You should consider selling them second hand in one of the many small-ads papers that offer a cheap, efficient way to sell unwanted items. Advertise the sofas at a good price, taking into account how much replacements will cost and how much money you will need to make up the difference. Then sit on them one last time and wait for the phone to ring.

> ## Tip
> Not all strong colours are a disaster in a neutral scheme – in fact, it is usually good to introduce something with punch in order to give the whole look some vibrancy. One bold-coloured piece (it could be an item of furniture, a rug or curtains) can anchor the rest of the design ingredients beautifully. It has to be planned for, though – annoyingly, it is rare that an existing piece does the job well.

DELICIOUS DECO

Q A relative of mine has moved abroad and has kindly given me her wonderful Art Deco sofa and chairs, upholstered in green and cream leather. I love them, but at the moment they completely dominate my small sitting room. How can I make the room work without carrying out any major alterations?

Your inheritance sounds like a complete dream. Without resorting to architects' plans to open up the space, a quicker and cheaper solution would be to paint the walls using the same creamy colour as on the leather sofa and chairs. You could also invest in an Art Deco uplighter or two. Relegate everything you can to another room and hide the necessary evils of CDs, magazines and books in low storage boxes. Tuck the television and sound system into a corner of the room, and banish trinkets, knick-knacks and all photographs that are not strictly necessary. Finally, crash out on your sofa and wallow in Thirties bliss.

ANIMAL MAGIC

Q I want to decorate my bedroom with several different types of animal print, such as zebra, giraffe and lion. How can I create a look that isn't excessively over the top?

Always buy the best animal print that you can afford – quality is far more important than quantity. There are lots of prints to choose from, so you shouldn't have to hunt around too far for some great-looking fabrics. Use your favourite print for the bedcover, which should be large enough to reach the floor. Edge this with a thick, plain cotton velvet border. It would be a good idea to paint the walls neutral, possibly white. With the other prints you choose, make some cushions to add to any other furniture you might have in the room. If you can afford them, some old leather armchairs would look great. I'd also make up an animal-print, kimono-style dressing gown, but perhaps I'm just getting carried away.

FIFTIES FLAVOUR

Q I have recently bought a house that still has a Fifties cooker in the kitchen. Rather than dumping it and going for a modern look, I am keen to use it as the central feature of a retro-style kitchen. How could I achieve this look?

The Fifties look is very popular at the moment. Old containers and gadgets can often be found at antiques markets and, if you're lucky, car boot sales. Look out for celadon biscuit jars and storage containers with labels. Anything in chrome is a 'must' – bar stools with chrome legs and red leatherette seats are the ultimate in Fifties chic. A black-and-white, checkerboard lino floor would also be appropriate, and you could continue the checkerboard theme on the walls by painting a strip of black-and-white squares at dado-rail height.

The last few years have seen an exciting burst of creativity among home-makers everywhere. It seems that suddenly everyone recognizes the potential of a can of paint and the right tools. As a result, basic stencilling techniques have given way to more sophisticated finishes, such as crackle glazing, frescoes and faux wood. Happily, manufacturers have picked up on this interest and researched ever-ingenious ways of making each task simpler and more effective. DIY stores are now as likely to stock gilding tools and fabric paints as power tools and stepladders.

If you haven't felt confident enough to join in before, now is the time to try it out. The kinds of technique described in this section do not depend on any particular product, nor are they confined to walls – floors and ceilings can also benefit from some artistic input. Remember, results are more to do with effort than acquiring complex skills.

You should find plenty of ideas to inspire you here, but if these solutions don't describe exactly what you had in mind, use them as a springboard to devise your own creative techniques. A little bit of experimentation can go a very long way indeed.

DecorativeTechniques

BAROQUE BLIND

Q I want to stencil a gold and silver pattern onto the cream fabric blinds in my bedroom. I have a baroque-style design in mind, comprising acanthus leaves or giant flowers. How should I go about it?

If you look closely at a damask fabric you will see the type of floral motifs you are looking for. I would suggest that you buy about 50cm (20in) of a fabric you like and use it as a pattern for an intricate stencil. Lay a piece of glass over the fabric to hold it flat, and stick a piece of plastic stencil sheet on the glass using spray adhesive. Use a scalpel or heat cutter to cut out the stencil. Then use a little more spray adhesive to hold the stencil against your blinds, and reproduce the pattern with a combination of silver and gold spray paints. Allow the paint to form a speckled effect in some places by altering the pressure on the nozzle of the can. Remember that fabrics decorated in this way should only be dry cleaned.

DIY STENCILS

Q I am keen to stencil beneath the dado rail in my bedroom and have found a print in an old book that I would very much like to reproduce. How do I turn it into a usable stencil design?

If you want to make a serious impact on your décor, forget the twiddly little 'round the door and along the dado rail' stencils, and take your print to a good photocopy shop where you can enlarge the design as much as you dare. A3 will probably be the biggest paper size you can use, but if you want to go larger you can tape a number of sheets together afterwards. With a black marker pen, block out those parts of the photocopied design that will eventually be seen as stencilled colour on the wall, but remember to leave a series of paper 'bridges' between the remaining parts of the design, as these will keep the finished stencil together. Apply spray mount to the design, and secure a piece of transparent stencil sheet on top, then use a craft knife to cut out the areas of marker pen. Peel off all the remnants and your stencil is ready to use.

HEAVENS ABOVE

Q I have taken down the hanging light in my bedroom. Although the room looks much better, the ceiling looks rather stark during the day. I have considered creating a tented ceiling, but I'm worried that it would be too 'fussy'.

Ceilings are often overlooked when rooms are decorated. The most common treatment is simply to paint them white and forget about them. But there are other possibilities. One of my favourites is to create the effect of a cloudy sky such as those you see in seventeenth-century landscape paintings. Visit your local art gallery for some postcards to use as a reference and recreate the cloudiness on your ceiling. Or even better, take a photograph of the sky when the clouds are looking good. Study the cloud formations and try reproducing them on paper.

Alternatively, there are several paint-effect books on the market that explain the process in step-by-step detail. The key to painting a convincing sky is to use only a few colours, invest in a good brush and allow lots of time. If you mess it up, simply paint over your work and start again. The effort will be well worth it.

CONCRETE PROPOSAL

Q I am in the process of renovating a flat in a Sixties block. I recently took up the carpets, and instead of finding floorboards, I was disappointed to discover unattractive concrete. I don't have the budget to lay a floating wood floor or a new fitted carpet. What can I do to make the room seem warm and welcoming which won't cost the earth?

If your ideal floor is wood, then why not try to simulate the effect with paint? So long as the surface is sound, brush on a layer of thinned PVA and leave it to dry. Next, working in sections, put on a layer of floor-levelling compound, 'skimming' the surface with a plasterer's float for a smooth finish. Just as the compound is on the point of setting, simulate boards by using a long strip of wood and the end of a flat-headed screwdriver to score long lines, about 2mm (⅛in) wide, into the drying surface. (Lay a piece of hardboard on the setting floor to access the farthest side of the room.) Intersect each 'floorboard' with occasional cross lines, as if one board was butted up to the next, so that you get as realistic a finish as possible. Allow the compound to dry completely, then paint a solid base colour over it (a warm honey would be ideal). Tint some acrylic floor varnish with a tube of white artists' acrylic colour. Varnish the floor with broad strokes, then use a woodgraining 'rocker' to pull a pattern through the wet glaze. Keep the graining lines neat and parallel to echo a real wood floor. Allow to dry, then use dark grey emulsion to paint the lines that would naturally occur between the boards. Finally, seal with an untinted layer of acrylic floor varnish. Once everything is dry, a soft chenille rug at the centre of the room would finish off the job to perfection.

Tip

Low-tack masking tape is a less sticky version of regular masking tape, and is invaluable when painting stripes, squares or straight-edged patterns on painted walls or furniture. Normal masking tape, no matter how slowly you peel it off, will almost always lift the paint behind it. If you are having trouble finding a supplier of low-tack tape, you can make your own simply by pressing a piece of regular masking tape onto a woollen carpet or a woolly jumper to reduce the stickiness.

LIME LIGHT

Q I love the idea of having a limestone floor in my hallway but it is too expensive. How can I create a convincing limestone finish for the walls instead?

Look for a suitable shade of khaki or taupe emulsion and paint a base colour of at least one coat over the entire hallway. For a sophisticated, smooth stone look, apply the paint and brush in a vertical direction, but for a more rustic look, use criss-cross colour-washing brushstrokes. Aim to brush the paint off in several directions as you work, then go back and give all the walls a second coat using the same technique. This will give you a build-up of colour and texture that recreates the appearance of limestone. Finish with a coat of matt acrylic varnish so that you can wipe away any marks.

BELOW SQUARES

Q We painted the floors of our flat white five years ago and are just about to give them a rub-down and another coat. How could we add some pattern?

First, clean the floor and give it the required coat of white paint. Once it is dry, mark out a geometric pattern of large squares with low-tack masking tape. Start at the centre of the floor and work outwards. The spaces between each square should be at least double the width of the tape. When the floor is masked off, paint the squares using a contrasting floor paint. A dove grey would look great against the white. Remove the tape as you paint, let the floor dry properly, and seal with at least two coats of acrylic floor varnish.

OUTER CIRCLES

Q I want to decorate my study with a bold pattern but can't find wallpaper that is suitable. Someone has mentioned stencils but I'm not keen on the idea. Can you suggest a simple pattern that I could create freehand without it looking too amateurish?

Bold patterns are very popular at the moment and would work well in a study. Mark a grid on all four walls and create a regular pattern of circles that look like the bull's-eye of a dartboard, with a central solid dot and two halo-style rings around it. You could then add short, spiky lines around the outer ring. You could draw around a jam jar for the centre, a slightly larger pickle jar for the second ring and perhaps the lid from a coffee tin for the outer ring. Finally, paint the circles in a colour of your choice.

LEARN YOUR STRIPES

Q I want to create a very subtle, dragged-stripe effect on my bedroom walls, similar to the old-fashioned dragging you often see on woodwork. I have chosen a pale pistachio green as a base colour, and I intend to use a darker tone of the same colour on top that will create minuscule vertical 'lines'. What technique and paints should I use to create this effect?

I hate to crush your enthusiasm before you begin, but I am sure you'll thank me in the long run: an over-dragged effect can look very dominant when it is used to decorate a whole room. A better option is to go for a striped effect instead. Paint the room in the palest colour first – in this case the pistachio – then draw the stripes using dressmakers' chalk, a long straight edge and a plumbline. There are two methods of painting in the second colour: you could use masking tape to create the edge of the stripes and to get a neat, crisp finish; alternatively, if you have a very steady hand, create an unfaltering brush line up against the edge of the chalk. Either method will give good results, but if you opt for the masking-tape method, make sure you use a proper 'low-tack' decorating tape on your newly painted walls, otherwise you will see all your efforts peeled away. Next, mix up an acrylic glaze and a little of the dark green emulsion. Use this for the dragged effect on the pistachio-coloured stripes, using a long-haired dragging brush. You'll also find that keeping the brushstrokes perfectly vertical is a lot easier when you have adjacent stripes to guide you. It is also possible to vary the texture of the stripes by painting a silver glaze over the paler colour.

BEACH BATHING

Q **I love the idea of a bathroom on a marine theme. How can I achieve the seaside look without resorting to the more obvious clichés such as framed shells?**

First, paint the walls using a soft, bluey-grey colour. Then I suggest you create a striking waist-high border made from short lengths of driftwood stuck vertically to the wall. It may take a while to collect the driftwood, but it will be well worth the effort – look for pieces that are long and thin, about 15–20cm (6–8in) long and 2.5cm (1in) wide. Use an epoxy resin glue to fix each piece of driftwood onto the wall in an upright position at about dado height and at least 30cm (12in) apart. Each piece of wood will be a different size and shape but this will add to the overall effect. Alternate each piece of driftwood with a mirror tile approximately 15–20cm (6–8in) square, which you can fix with the same adhesive. Towels should be white, ice-blue or grey – and there shouldn't be a single starfish or seashell in sight.

Tip

It is easy to dismiss themed rooms, as they often seem contrived and old-fashioned by today's standards. The trick is not to state the obvious, but to take inspiration from a more lateral point of view – after all, you are designing a home, not a film set. A beach theme does not necessarily call for a seaside mural and everything studded with shells; it can be achieved more subtly through colours, textures and sea-washed timber. Similarly, a Fifties retro look need not resemble a museum piece – it can be suggested through just one carefully chosen motif, pattern or object.

HOLIDAY ROMANCE

Q Having returned from a holiday in Morocco, I am keen to give my bedroom an exotic Bedouin-style look. I am going to hang ethnic fabrics on the walls and have a low-level bed. One particularly vivid memory of the trip was of the wonderful sand dunes at dusk. How can I paint my wardrobe doors to look like a desert scene at night?

A quick flick through a picture book of the *Arabian Nights* would supply you with all the reference material you could possibly need. My ancient copy of the *Rubaiyat of Omar Khayyam* (illustrated by Edmund Dulac) has also proved interesting. Once you have found the picture you want to recreate, you will have to transfer it to the doors. If you are confident enough to paint the picture on directly, first draw pencil lines in a uniform grid of 15cm (6in) squares to make mapping it out simpler. Another option is to trace the image from the book and have it copied onto clear film, which you can then use with an overhead projector. Use the original picture for colour reference and work with artists' acrylic colours. Once you have finished, protect and seal the doors with two coats of acrylic varnish.

AMAZING GLAZE

Q How do I paint the walls of my bathroom in a finish that is similar to the beautiful green crackle glaze on a vase that I have just bought?

Crackle glaze occurs in the glazing process of some ceramics. The look can also be reproduced on almost any other surface using a special varnish. On a wall, the process will be fairly pricey and also time-consuming (allow at least three days). Two coats of an emulsion base colour will be needed, then a layer of crackle glaze. Once this is dry, apply the second layer of varnish when the crackled effect will start to appear (you can speed up the process with a warm hairdryer). You should then highlight the cracks with a brown 'highlighting medium'.

FRESCO DELIGHT

Q How do I mix a water-based glaze so that I can over-paint an existing dark blue colour in order to create a subtle fresco finish?

One of my favourite paint finishes is the soft, cloudy effect reminiscent of old fresco paintings. Start by holding a colour card up against the painted wall. Look at your base colour carefully and find a mid-tone colour of a similar but lighter hue. Mix together one part mid-tone blue paint, one part water and one part acrylic scumble glaze. Take a 10cm (4in) wide brush and paint this colour onto the walls. Aim for large, sweeping brushstrokes in all directions, working the brush to the point where the bristles are splayed. When this coat is finished, mix up a second colour using one part of the same mid-tone blue, one part white emulsion, one part water and one part acrylic glaze. When this coat of glaze has dried, repeat the brush technique, only this time apply the colour in a slightly more patchy manner than before, aiming for a dappled, cloudy effect. Finally, apply a coat of white glaze (equal parts white emulsion, water and glaze). Brush on patchily as before to complete the fresco effect.

MIX YOUR OWN PAINT

Q I have heard that you can make your own paint with powdered pigments, but I don't know what ingredients to use. What do I need to create a paint that has a soft milky finish?

Making paint isn't nearly as difficult as it might seem. There is nothing simpler than combining the humble ingredients of water, binders and pigment. The most basic ingredients such as egg yolk and milk can be used as natural binders that will stick the pigment onto walls or furniture. Try separating and straining skimmed milk curds and mixing them with a little colour pigment to produce a beautiful paint that is ideal for small items of furniture. Alternatively, egg yolk – once it has been removed from its delicate sac – can be mixed with a dash of cold water and powder pigment to produce a finish that is soft and velvety.

AGE BEFORE BEAUTY

Q I bought some inexpensive floral wallpaper that would be perfect if the colours weren't quite so vivid. I have noticed that many good quality wallpapers have a toned-down, aged appearance. Is there a wash or glaze I can use to achieve a similar effect?

Unless you can encourage a team of Gitanes-smoking Frenchmen to spend two weeks puffing away in your floral room, the only alternative is to mix a dab of burnt sienna acrylic artists' colour with a little acrylic scumble glaze. Add more glaze to make up 500ml (18fl oz) and apply with a wallpaper brush. Brush out to achieve a gently aged appearance. The more glaze you use, the deeper the colour and the greater the ageing effect. To achieve a more rustic finish, you should apply the glaze in patches. Do a test first to see which look you prefer.

CHEMICAL BOTHERS

Q I have painted my newly stripped walls and the paint has cracked and blistered. What do I do?

There is a chemical reaction between the new paint and the newly stripped surface. Quite often this is caused by a reaction between the composition of the original paint underneath and the new top coat. But whatever the cause, the treatment is always the same. Scrape off the blistered paint, then fill and sand the affected parts to achieve a perfectly smooth surface. Dilute one part PVA adhesive (available from DIY stores and hardware shops) with one part water, and brush this over the walls. Leave to dry. Apply the next coat of paint and you shouldn't have any further problems.

REFLECT ACTION

Q We have a very small dining room that gets hardly any natural light. One solution I have thought of is to have at least one of the walls mirrored. How should I go about it?

Mirrored walls can look beautiful but you must have a perfectly smooth surface, as lumps or bumps will ruin the streamlined look. If you get mirror tiles cut by a glazier, make sure all the edges are polished. You will also need a large amount of the recommended adhesive. Use a pencil and a spirit level to mark a horizontal line along the centre of the wall. Then mark a vertical central line. Stick the tiles to the walls, starting from the centre where the lines intersect, working outwards and upwards before working downwards and outwards to the top and bottom edges. You can fix tiles right up to the edges of the walls, or finish about 40cm (16in) from the ceiling and walls, and about 50cm (20in) from the skirting boards, giving the impression of an enormous reflective wall that seems to float.

Just as people have discovered the joy of making their own decorative finishes in recent years, so there has been a resurgence of needle skills. In part, this is probably due to the expense of buying many soft furnishings new. For anyone on a budget – and that includes most of us when we move house – it has become essential to have a go at making curtains and covers ourselves.

The great thing is that you don't have to know all the correct techniques in order to create something that looks glorious. There are quick routes to success, which once learnt can open up new ways of tackling all kinds of related tasks. Soft furnishings are not confined to windows either – cushions, chair covers, bedheads and throws all come into this section as well. Nor are they limited to the use of conventional furnishing fabric. There are ideas on everything here, from printing your own designs to making lavish use of inexpensive substitutes such as bedlinen, fabric remnants, bath towels and blankets.

One thing is certain: soft furnishings make a room seem immediately more welcoming and comfortable. In this respect, they go right to the heart of a scheme and are a vital element of the home.

SoftFurnishings

A HEAD START

Q I am looking for a headboard that has a polished wood frame around a fabric centre. I want something more elegant than a fully upholstered headboard but so far have had no luck finding one. What can I do?

First, measure the required size of the bedhead. It can be either square or rectangular in shape and it is best if it is generously proportioned. Ask your timber merchant or DIY store to cut the board for you. Staple heavy wadding over it and cover it tightly with fabric which overlaps the edges so that it can be stapled to the reverse side. Mark out a square or rectangle at the centre of the upholstered board using masking tape, and paint the centre with silver fabric paint. When the paint is dry, fix it with a warm iron. Screw the board against the wall so that its base lies just below the top of the mattress. You can then add picture moulding to finish the three visible edges. Use long screws to fix the moulding in place, having first countersunk the drill holes. Finally, fill the holes with woodfiller.

BOARD GAME

Q We have just bought a queen size bed that needs a headboard. I'm not keen on any of those I've seen in the shops, so I thought I'd make my own. Do you have any suggestions for a simple headboard that could be wall-mounted?

You can make a stunning headboard by fixing a series of rectangular, upholstered panels to the wall above the bed. First, cut nine 50 x 30cm (20 x 12in) pieces of 6mm (¼in) thick plywood. Using strong adhesive, attach a layer of 6mm (¼in) thick foam rubber to each piece. Next, cover the foam rubber with fabric, pulling it taut before fixing it to the back of the board with a staple gun. (A colourful effect can be achieved by using a different coloured fabric for each panel, or, for a more subtle look, you could use a combination of neutral shades.) Secure the rectangles to the wall horizontally using mirror-fixing plates. Attach three panels along the width of the bed, leaving a gap between each board, then attach a second row above the first. Finally, secure the top row in the same way.

TONE IT DOWN

Q **Our black ash dining table and chairs look too dark and heavy as we have recently painted our dining-room walls white, laid a mid-blue carpet, and hung blue, white and yellow curtains. How would you give the furniture a modern twist?**

One of the simplest ways to disguise your tired furniture is to use some fabric. Chairs look chic with simple drop-over covers made from linen or pure cotton. Avoid frills, ruffles and patterned fabric. Instead, opt for an intense cobalt blue or white. First, make up a pattern with newspaper, pinning pieces of paper over the seat, the back and around the sides – adjusting them for a snug, but not too tight, fit. Sew the pieces together and fit over the chair. If you feel the backs of the chairs need detail, sew on a couple of mother-of-pearl buttons. Now, turn your attention to the table. Wide table runners look very sophisticated – yours should be cut from a mid-blue cotton and cover as much of the table as possible, but leave about 10cm (4in) free on each side. Finish with starched white napkins, clear glassware and white bone china for a stylish look.

COVER STORY

Q **How can I make a simple slip cover for our tatty director's chair?**

First, you will need to determine how much fabric will be required. Measure each facet of the chair, adding 4cm (1½in) all around to allow for a loose fit and 2cm (¾in) seams, then mark out the pattern pieces on brown parcel paper. Cut them out and pin them over the chair, keeping the seam allowance on the outside so that you can make adjustments where necessary. Mark each pattern piece clearly, then unpin them and lay them out as if on a length of fabric. Decide on the quantity and type of fabric you will need. When you come to sew up the cover, be sure to stitch each seam twice for strength.

FAUX ZEBRA

Q I would like to re-cover my conservatory furniture in a cotton zebra-print cloth, but I can find only fluffy fake fur or dress fabrics. Any suggestions?

Have you considered printing your own fabric? All you need is a good quality cream canvas and several pots of black fabric paint. Take inspiration for your pattern from a trip to the zoo, or browse through a second-hand bookshop for back copies of the *National Geographic* magazine. Draw your design onto a piece of paper, the width of which measures the width of your fabric. Once you are satisfied with the design, transfer your pattern onto the canvas using the tracing method. Repeat the tracing until you have enough fabric to cover your furniture. Paint on the fabric colour, wait for this to dry, cover with a cloth, and then fix the paint with a hot iron.

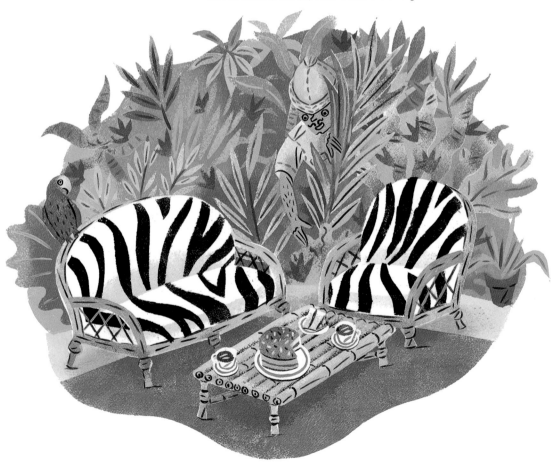

DAZZLING DOTS

Q At a recent car boot sale I picked up a beautiful chair with a distressed white frame. I would love to re-upholster it but so far I haven't found a fabric I like. What kind of paint and fabric should I use if I want to have a go myself?

You can easily create an inexpensive but unique fabric by decorating natural linen or canvas with special fabric paints. If you want a mushroom-taupe background, opt for artists' linen. For a creamy background, choose artists' cotton duck. One good idea is to create a pattern comprising a series of circles made up of dots. Make the circles about the size of a dinner plate. Create a pattern of dots that spiral from the centre outwards, or paint a series of simple circles within circles.

DYEING TO PLEASE

Q Can you tell me how to make curtains on a budget? I want very broad, blackish-brown vertical stripes on a cream background.

For your curtains, I would use natural linen, which can be very inexpensive if you shop around. Dye half of the fabric to achieve the blackish-brown tone you want. (This is much better than using fabric paint because creating such wide stripes would be quite expensive.) Cut both the dyed and undyed linen into long, wide strips. Sew alternating strips of dyed and undyed fabric together to get the effect you want. Hem the curtains and sew on a heading tape for a traditional look, or you can use curtain clips to secure the fabric onto a pole.

LAVISH WITH LINEN

Q I have inherited a pile of glorious, white, pure linen sheets. However, they are all wearing thin in the middle. I know the traditional solution is to cut down the middle and restitch the sides together, but have you any ideas as to how I could put them to better use?

If you have masses of linen, you can afford to go completely mad: hang pure linen in the windows (sew strips together, add ties and knot onto a pole), make a drop cover with box pleats for a chair, and oversized cushion covers with mother of-pearl buttons. You could also sew any remaining linen into a sumptuous duvet cover. But rather than simply making a plain cover, cut the linen into strips and squares, and mix it with another type of fabric. Creamy white satin would look great; the matt texture of linen mixed with glossy satin is a dream.

> **Tip**
>
> If curtain rings won't glide properly, apply a lacquer spray over the painted surface of the curtain pole. Once dry, this should be tough and smooth, and provide a permanent solution to the problem. As a temporary measure, however, rub the pole with soap or candle wax.

CURTAINS UP

Q I have been given some heavy, full-length, velvet curtains. Although they are rather faded, they are too good to throw away. Any ideas?

Strip the curtains back to the very basics: remove the linings and heading tape, and unpick the hems. Cut the velvet into long, wide strips, no less than 20cm (8in) across. Then cut a length of plain cotton fabric into strips and sew these between the velvet pieces to reassemble the curtains. Use fabrics of a similar colour for an elegant look, or contrasting colours for a bolder effect. Line the curtains, then add darts along the top edge at regular spaces to take in some of the fullness; finally, add ties to knot each curtain onto the curtain pole.

FADED GLORY

Q I recently bought some beautiful, but slightly moth-eaten, aged chintz curtains. Having hung them, I realize that they look far more shabby than chic. Do you have any suggestions as to how I can overhaul them?

Old fabrics often have beautiful faded colours and a glorious texture that is hard to find in pristine, modern, factory-finished fabrics. However, as you have found, they can also be extremely fragile, and I think that it would be difficult to use yours as they are. But all is not lost: cut up the old curtains carefully, and salvage the largest possible piece of fabric and as many broad strips as you can. If you are lucky, you might have a piece that you can make into a small pair of curtains, although you will have to edge them with natural-coloured linen. If you are left with any broad strips, cut more strips of natural linen to the same width, and stitch them together before remaking into 'patchwork' curtains. Any smaller strips can be used to make items such as cushions or tiebacks.

AWKWARD SITUATION

Q **I have a square bedroom window with a triangular top, all of which is glazed. What kind of curtains would you suggest? I want to maximize the daylight but I also want to close the curtains at night.**

The best solution would be first to fix a curtain pole that is as wide as the main window above the triangular section. Next, choose your fabric and fold over 15cm (6in) at the top edge of each curtain. Sew two lines of stitching, one 5cm (2in) from the top and the other 10cm (4in) from the top, to create a channel. Slide the two curtains onto the pole and fix up at the window. Gather up the fullness of the fabric along the pole and arrange the folds neatly. At the point where the curtains meet the square part of the window, fix a metal holdback and gather each curtain behind these. Simply unhook the curtains from the holdbacks to close them.

> **Tip**
>
> If you are looking for a smart alternative to plastic curtain rails and pelmets, check out your local plumbers' merchant. Long lengths of copper piping are inexpensive, and when rubbed with wire wool they look great. If you have a bay window, make a full-size paper template of the bay, then hire a pipe-bending tool to match the copper pipe with the curve of the window. Polish the copper using fine-grade wire wool, then seal it with a transparent spray lacquer or varnish. Fix the piping to the wall with wardrobe rail brackets, remembering to thread on the curtain rings first. Very cheap, very chic.

SHEER DELIGHT

Q I dislike the net curtains in my kitchen but I need them, as my window overlooks my neighbours' window. Do you have any simple, good-looking solutions?

Throw the old net into a white wash. Once it is dry, cut it to the same size as the window that needs covering, adding 2.5cm (1in) to each side and to the top for hemming. Add 5cm (2in) at the bottom for a deep pocket hem. Stitch the edges, then thread a bamboo cane into the lower hem. Cut two long pieces of white organza ribbon, each piece measuring twice the length of the blind. Fold the ribbons over the top of the blind, approximately 15cm (6in) in from each side so that they hang down equally front and back. Then secure the blind at the top of the window using Velcro tape or a staple gun. Now roll the bottom of the blind and bamboo to the height you want, and tie off the ribbons in a loose knot or bow so that the blind will hang neatly.

GOING PRIVATE

Q I have just rented a house with some college friends and I am going to have the sitting room as a bedroom. It has wonderful French windows that lead to the garden, but I am worried about being overlooked. Do you have any suggestions for a cheap way of dressing the windows so that I have some privacy but don't lose too much light?

Second-hand shops are fantastic sources of good old-fashioned linen sheets, which could be transformed into fabulous curtains. The cheapest are invariably worn in the centre, but they can still be used with the help of a piece of semi-transparent fabric such as silk organza or cotton organdie. First, pin a panel of the fabric in the centre of each linen sheet where it is worn, then attach it with a close zig-zag stitch, trimming off any stray threads. Next, with the linen facing upwards, carefully cut out a rectangle of the worn material to reveal the semi-transparent panel; trim any loose threads. Hang the sheets on the curtain pole using ribbons or tab tops.

POLE PROBLEMS

Q As there is no gap between the top of my bedroom windows and the ceiling, it is difficult to decide how to hang curtains. I want a pole but I am worried that because of the lack of space, light would filter through between the pole and the top edge of the window.

Hanging curtain poles when space is limited can be a real problem. The only solution I have found is to hang the curtains directly onto the pole with the top tightly gathered. The fabric should be sufficiently 'scrunched up' to stop the light coming in. You won't be able to draw the curtains, but during the day you can pull them aside with tiebacks. As the pole will not be seen, it is pointless to buy an expensive fitting. Use a chunky dowelling rod or a broom handle and invest in a set of glamorous finials. Suspend the pole as high as possible and make curtains that drop to the floor. Sew a strip of fabric along the back of each curtain to create a 'pocket' into which you can slide the pole. The depth of fabric above the pocket should be the same as the distance from pole to ceiling. The pocket should be wide enough to allow the pole to pass through but also tight enough to make the fabric form tight little folds. Tuck the fabric above the pole so that it stands up like a pie crust. Secure the pole onto its fittings (heavy-duty cup hooks would work well if you have used a broom handle or dowelling). Now all you have to do is to fix up the finials and the tiebacks.

VOILE-LÀ!

Q I recently went on holiday to Kenya and stayed in a wonderful hotel room with a mosquito net. How would you go about making one?

Mosquito nets can be bought from most camping shops. To make your own, decide on the length of your fabric and then cut three widths to the right measurement. Fold each length about 30cm (12in) down from the top edge, then stitch a channel about 2.5cm (1in) deep along each of the folds. Pass a hoop (about 45cm [18in] in diameter) through each channel (a broken child's hoop or a length of plastic tubing would serve the purpose) and join the two ends with packaging tape. Spread the channel evenly around the hoop before gathering, and then stitch the top edges onto a large curtain ring. Hem the bottom of the fabric drops and hang the net from a hook on the ceiling.

CUSHY NUMBER

Q My daughter has rented an unfurnished flat and wants floor cushions to supplement her one tatty sofa. Do you have any ideas?

To make up three or four cushions, dye some old bath towels black. For each cushion, cut a towel into a piece that is at least 75cm (30in) square. Cut a similar piece for the back, adding an extra 5cm (2in) on one side for a zip fastening. Cut four side pieces that are about 7.5cm (3in) deep and 75cm (30in) long. Cut the back section in half and sew in a long zip. Stitch the side pieces together, then stitch to the front and back. Make a cushion lining cover from cheap cotton calico (with no zip). Make it in much the same way as before, leaving a 15cm (6in) gap in one seam. Fill the cushion with polystyrene beanbag filling, then sew the gap with small stitches so that the beans don't fall out. Finally, stuff this into the towelling cover, then treat yourself to a new set of fluffy bath towels.

ON THE BUTTON

Q I have made a pair of cream curtains but I am uninspired by ready-made tiebacks in the shops. Do you have any bright ideas?

Ready-made tiebacks can be rather dull. Here is one of my favourite alternatives which would look particularly good with your curtains. Cut out two 20cm (8in) wide discs of MDF or plywood and cover each with a matching piece of upholstery wadding or foam. Mark a circle around each disc on a piece of cotton duck or canvas (when cutting, leave a 2.5cm [1in] excess around the circumference). Sew white, cream or pearly buttons over the entire surface of the circle so that none of the fabric shows. Use buttons of different shapes and sizes – junk shops, flea markets and car boot sales are good hunting grounds for old buttons. Cover the disc with the fabric and fix with glue or staples underneath. Use epoxy resin glue to secure one 15cm (6in) length of 2.5cm (1in) dowelling to the underside of each disc, and use double-ended dowel screws to secure each circle to the wall.

A TOUCH OF SUMMER

Q How can I make a lightweight summer throw?

Combine squares of fluffy lilac mohair with cream or white waffle towelling fabric. You can buy both off the roll, or scour charity shops for an old mohair rug and buy a large waffle towel. Cut both fabrics into squares; aim for a throw with a total of 16 squares, each measuring 30cm (12in). Sew the squares together in a checkerboard pattern, back the throw using cotton calico and bind the edges with a broad satin ribbon. Finally, sew small ribbon roses where the corners of the squares meet.

BLANKET COVERAGE

Q I rent a flat that has a Seventies wardrobe with long mirrors on the front of the two doors. Can you suggest a temporary solution to its really hideous looks?

Fix a pair of long, chrome door handles across the top of each cupboard door and make two simple curtains to hang from these. An old Welsh blanket would be at the top of my wish list for this particular project – look in second-hand shops or antique shops. Sew on a simple tab, or tie headings to each curtain using upholstery tape or linen ties. Sew curtain weights into the bottom hem to keep them straight.

WOOLLY THOUGHTS

Q I have two lovely old grey blankets that I want to update in some way – one as a throw to put on a sofa, the other to use as a bed cover. Have you any suggestions?

Create a stunning throw with a neat row of blanket stitches, in a contrasting or complementary colour, around the edge of one of them. For the bed cover, edge the second blanket with either red felt or wool trim. (Make this by cutting strips from lengths of cloth.) First, sew the trim around the edges of the blanket. Turn it over the edges and then stitch to the reverse. I would also mitre the corners so that it has a clean-looking finish.

NO FRILLS

Q Is there any alternative to a frilly valance covering the base of my divan bed?

In my life there is always an alternative to frills. It is a simple job to make a straight-sided valance with deep box pleats for the two corners at the bottom of the bed. It is simpler still to leave the corners 'open' if the thought of pleating (i.e. sewing three 'sides' onto a piece of fabric cut to the size of the bed) means that you'll never get the job done. Set aside an hour or so for making the valance without the box pleats, and then say goodbye to those frills for ever.

COVER-UP

Q A friend has suggested that I cover the flat, modern doors in my sitting room and hall with fabric. How do I go about it?

There are two different methods. The first is to use an old-fashioned 'portière'-style rod, which holds a full-length curtain over the door. This will swing the curtain to and fro when you open the door. Alternatively, you could staple fabric directly on to the door. Use a length of fabric that is the height of the door and twice the width. Remove the handles and staple the four corners of the fabric to the corners of the door. Next, staple the centre top and bottom of the fabric to the centre top and bottom of the door. Take up the remaining slack with a series of pleats, held in place with more staples, then staple the sides. Glue narrow grosgrain ribbon over the staples and protect the fabric with a stain-resisting spray. Finally, make a small cut in the fabric where the handles should go and replace them.

S tyling a room well is all about adding those extra things that bring life and character to a space. It might be pictures on the wall, a fabulous floral display, or one fantastic mirror. Equally, it might be more to do with introducing a particular atmosphere, such as oriental tranquillity or a contemporary buzz. What matters is the impact that is made and the way a scheme can be brought together in one final flourish.

There is a lot of fun to be had in these pages, from making handles for kitchen cabinets to designing and painting your own art work. There is also advice on common queries, such as how best to hang a series of pictures, or how to display to advantage a much-loved collection of three-dimensional objects.

Many of these suggestions can be adopted either as the final part of designing an entire room scheme, or as an independent idea to replicate in your own home. You will find some great gift ideas here, too, if you would like to channel some of your creative energy into making something for someone else. Whatever you decide, these finishing touches will probably be only the start of some fabulous inspiration of your own.

Finishing Touches

3-D DISPLAY

Q Over the past decade, I have amassed a collection of blue-and-white china plates, urns, teapots, cups, bowls and platters. Some of it matches, but most of it doesn't, so together it looks rather ramshackle. I have neither the space nor the money for a dresser. How can I show off the collection in some quirky way?

Fix a high shelf on a wall at about picture-rail height. It should be about 7.5cm (3in) thick, but only project forward about 15cm (6in), and it should continue around at least one corner of the room. At this height, all the necessary fixings should be above the shelf rather than below it so that they can't be seen. Place your collection on its new high-rise accommodation as if it were a frieze. For added effect, larger items can be displayed individually on smaller shelves of similar construction placed lower down on the wall.

GLASSY NUMBER

Q Have you any suggestions for decorating the plain glass panel above my front door in a way that incorporates the number of our house?

Create a simple, minimalist look by using glass etch spray to 'frost' the panel. You will need to make a template of your house number first to mask off the area that will remain unsprayed. If you are feeling brave, draw this freehand onto a card. If not, look for a style of number that you like and enlarge it on a photocopier. The number should be as large as possible, but must not appear squashed into the panel. Cut out your number and use double-sided sticky tape to fix it to the inside of the window – with the number facing right side out. Apply glass etch spray to the panel, following the manufacturer's instructions. Allow it to dry, then peel off the number to reveal a 'frosted glass' window that looks like the real thing.

ODDS WIN

Q I love collecting odd pieces of china that I have picked up at markets and car boot sales. I now have enough dinner plates, side plates and bowls for twelve settings. The only problem is that none of them matches. When I put the whole lot together, the overall effect was described by my boyfriend as 'supper time in a squat'. Can you suggest a way for me to smarten up my collection?

You can't disguise the fact that nothing matches, but it helps to keep the backdrop as neutral as possible. Cover the table with a white tablecloth that is large enough to hang generously over the sides. Add some white napkins and lay the table as usual, then shred the petals from at least four or five scented flowers and scatter the table with them. Make sure that you have a variety of colours. Try mixing delphiniums, roses, apple blossom or ranunculi – whatever flowers are cheap and in season. Fill pretty teacups with nightlight candles, pop a little lavender oil on some saucers and put them on top of a radiator. The effect will be so stunning that no one will notice your clashing china.

MAT VARNISH

Q Can you suggest a way of making a set of placemats that would look good with my jumble of floral china?

Your best bet is a bit of cutting and pasting to create a set of modern découpage placemats. Look around for seed packets, gardening magazines and floral wrapping paper. Pictures of roses, delphiniums, geraniums and hellebores would be perfect. Use a pair of paper scissors and start cutting. Then split up the flower cut-outs into groups so that you have enough to make six or eight mats. Take the flowers to a photocopying shop and arrange each group between two clear laminating sheets. Whizz them through the laminator and a minute later perfect floral placemats will emerge.

HOOKS WITH LOOKS

Q I need a set of coathooks for my hallway. As it is sparsely decorated, it would be nice to have something over the top. Any ideas?

Go for something witty. Scour antiques markets and junk shops and buy three (or more) two-armed, metal candle sconces. It doesn't matter if they don't match or are fitted for electric lights as the wiring can easily be stripped out. You might want to remove sharp ends with a hacksaw and then smooth down the metal using a wire-brush attachment on a power drill. Fix the sconces to the wall, ideally at above-head height so that the arms are higher than eye level. Now you can hang your coats, umbrellas, hats and bags from them.

LIGHT FANTASTIC

Q I would love a quirky ceiling light in my kitchen. Could you suggest something that is good looking but inexpensive?

Cut an MDF or plywood collar to fit around the rim of a large cone-shaped sieve and then paint it silver. Using lengths of plug chain, suspend the collar and cone from a hook on the ceiling. The light fitting can be hidden from view inside the sieve. Drill holes through the collar and hang loops of beaded plug chains. Use these to hang aluminium tea strainers, pastry cutters or anything else that catches your eye in the kitchen shop. Around the top of the collar, glue some glass espresso cups and saucers that can be used as candle holders.

> **Tip**
>
> It's not only lights that are easy to custom-make. Inexpensive clock mechanisms, available through craft suppliers, can be used to transform all manner of household items into chic clocks. Drill a hole centrally in the bottom of a colander, for example, then fit the mechanism and hands in place for an unusual kitchen clock.

DAZZLING DISPLAY

Q My uncle has given me a collection of ten wonderful technical drawings which were made for a foundry during the Thirties. Some are gryphons, others acanthus details for chandeliers. How would you suggest I frame them in a simple but stylish manner that is suitable for a dining room?

The most striking effect would be to hang all the pictures together in a horizontal band around the four walls of your dining room. First, measure the available wall space, taking into account windows, architectural details and the shape of the room. Then position the unframed drawings on the wall with multi-purpose tack to assess how they look. Space the drawings evenly and decide how far apart they should be. This will tell you what size and thickness of frame to choose. I would suggest your frame surrounds be at least 5cm (2in) wide; a dark colour would suit the graphic quality of the pictures. Instead of mounting the drawings on card, use creamy, handmade paper, then hang the pictures so that each is perfectly aligned.

COLLECTING YOUR THOUGHTS

Q For the past decade I have travelled extensively in northern Africa and Asia. I have returned from each trip with a holdall full of ethnic pottery, rugs and knick-knacks. My flat now looks like a bazaar. I am very attached to most of what I have collected but it is cramping my style. Do you have any suggestions?

First of all, you should have a complete clearout of everything in the flat. Put the whole lot into cardboard boxes. This will give you a good opportunity to repaint the walls. When you have cleared every room, you should start putting your collection back, beginning with your favourites. Make sure that everything you return is part of the room's overall design. If you have a collection of similar objects, group them together and if possible hang them on a wall. Smaller items are more eye-catching if they are put in display boxes. This sifting process will help you work out which things you can live without. Exercise control and you will have a collection that is easier to look at – not one that bombards you visually.

PRINTS CHARMING

Q I have started collecting old frames but have nothing to put in them. Prints seem to be quite expensive, particularly anything unusual or quirky. Do you have any tips?

Using the photocopier is always a good way to produce inexpensive 'art'. I often find good source material in books of prints, covering subjects from botanical flower engravings to architectural plans and mythological beasts – look for something you are passionate about. If possible, copy the image onto good quality, handmade paper, then add washes of cold tea to give them a sepia tone. A sprinkling of instant coffee when they are still wet will add convincing fly spots. Alternatively, you can use your frames to display three-dimensional objects such as fossils, shells, old teaspoons or seed pods. Try sticking a backing paper into the frame (many stationers sell beautiful wrapping paper decorated with calligraphy designs). Finally, glue on squares of silver Dutch metal leaf, available from most good art shops, and then display your chosen object in the middle. The effect is stunning.

> **Tip**
>
> Deep-sided box frames – or shadow frames as they are known – offer the perfect way to display three-dimensional objects. Mount objects on creamy, handmade, textured paper and hold them in position with silver dressmakers' pins.

PRESSING BUSINESS

Q I have a large collection of pressed flowers and leaves that I would like to display in a simple, original way. Do you have any suggestions?

The most effective way of showing off your collection is to frame it between sheets of picture glass. Aim to produce three to five pictures that you can display on a mantelpiece or shelf. Alternatively, you could fix a narrow batten on a wall at eye level, paint it silver and prop the pictures between the batten and the wall. Divide the flowers into groups and lay them on the sheets of glass. Once you have decided on the layout, hold the flowers in position with a spot of glue. Next, sandwich the two pieces of glass together and secure with sticky-backed foil tape around all four sides. Foil tape is available at stained glass suppliers – although you may prefer to use silver or black gaffer photography tape.

HANGING GARDENS

Q My sister is getting married this summer and wants some unusual floral decorations for the lunch tables. I did read about a florist who submerges flowers under water. It sounds brilliant and I know my sister would find it amusing, but how do you do it?

Choose some interestingly shaped flowers such as gerberas, lilies, roses, sweetpeas and maybe some green leaves. Fill the glass vase with water to about 2.5cm (1in) from the top, and 'hang' the flowers in the water by wrapping fishing-line – weighted with pebbles – either around the stem or by the base of the flowerhead. Ideally, the vases should be large and a simple shape – such as square or cylindrical. The flowers will not last as long as usual, so do not be tempted to make the arrangements too far in advance. It is also worth having a trial run before the big day.

PLANTING IDEAS

Q I would like a plant stand for a corner of my conservatory. I have searched the high street and garden centres but the ones they sell seem to be rather ornate. Do you have any suggestions for a cheap, simple alternative that I could make myself?

Construct a series of five or six slatted, wooden corner shelves, which would give you a floor-to-ceiling plant display. These would be fairly easy to make using lengths of 5 x 2.5cm (2 x 1in) battens. Another option is to use hanging baskets to create a 'growing chandelier' arrangement. With a little thought, the effect can be stunning. Use three baskets – one small, one medium and one large – and attach chains to each so that they hang in a line. Pack each one with plants, and then suspend them from another chain on a hook attached to the ceiling so that the middle basket is at about eye level. This will mean that the bottom basket will be about 50cm (20in) from the floor.

EASTERN PROMISE

Q My bathroom walls are cream, with cream-painted wooden panelling and a white bath and basin. I want to create an oriental style. Where can I buy objects and items that will complete the look?

If you live near a big city, you may have already discovered the delights of Chinese supermarkets. Among the frozen ducks' feet and dried pigs' tails, you will find pretty bamboo steamers that are great for stacking and for storing toiletries and make-up. Also look out for delicate porcelain rice bowls and sake cups. Five rice bowls positioned along a shelf will look great, and provide more useful storage. Copy examples of Chinese calligraphy onto sheets of handmade paper and clip them into simple black frames to hang on the walls. The oriental look is very fashionable at the moment, so you should find Chinese- and Japanese-inspired accessories at many high street stores. If you have the space, add a dramatic plant or flower. Lengths of living green bamboo can be bought from good florists. Push the canes into a large, glass, tank-type container and then fill it with rounded pebbles.

STONE AGE

Q I want a white bathroom with white tiles, white walls and white accessories. However, I want to give the room a twist – some sculptural element that will act as a focal point. Do you have any ideas?

Natural tones look perfect with all those clinical white surfaces. You could pile up coloured stones to make natural sculptures. Surround yourself with little luxuries: chunky handmade soaps, lots of waffle towels and a thick towelling bathrobe – preferably all in shades of cream and taupe. Buy some aluminium or brushed-steel accessories: towel rails, storage containers and a tooth mug. Then draw the whole effect together with a huge mirror – a perfect choice would be one framed with roughly hewn slate. Finally, add scented candles and aromatherapy bath oils – vanilla or frankincense fragrances get my vote.

COOL REFLECTIONS

Q **Please can you tell me how to make a large – but cheap – mirror for my bathroom?**

Mirror tiles can look ghastly, but it is possible to use them creatively. Buy 24 mirror tiles that are 10cm (4in) square and a tube of strong panel adhesive. Carefully plot out the position of the mirrored area on the wall using a measuring tape, ruler and spirit level. Measure this area, and working on the floor, lay out the small mirror tiles to create a border to those measurements. You will need to adapt the size of the mirror so that you don't have to cut any of the tiles. Once you have the border laid out, measure the space inside it, as this is the exact size you will need for the central mirror panel. Ask a glazier to cut this for you and ask for all the edges to be polished. Mark out the position of the large mirror on the wall and screw a temporary 5cm x 2.5cm (2in x 1in) batten along the bottom edge. Apply panel adhesive to the underside of the mirror, rest it on the batten and press it firmly in place on the wall. Hold for a few minutes and then release it. Allow the adhesive to set overnight and then remove the batten. Fix the border tiles in place in the same way, using more panel adhesive. Put the tiles tightly together so there are no gaps – the idea is to have an exact border around the central pane of glass.

Tip

A beautiful antique-looking mirror can easily be created by placing 'aged' mirror glass into an old picture frame. To 'age' the mirror, apply an even coat of paint stripper to the back. This will make the grey protective layer blister. Remove it after about an hour, then apply a second coat and leave it over night. Rub away the dried stripper with wire wool, then go over the surface again, etching away parts of the silver coat to expose areas of clear glass. Continue the process until you are happy with the finish, then rinse the surface with warm soapy water and frame your 'old' mirror.

SHELL CHIC

Q Over the years I have amassed a huge collection of seashells, and I now want to use these to create a mirror surround in my sitting room. How do I go about it?

First, decide on the position of the mirror and how big you want it to be. Cut a piece of 12mm (½in) plywood or MDF accordingly, and sand the edges smooth. Use panel adhesive to secure the mirror at the centre of this, allowing for a deep border, at least 20cm (8in) wide, all around. Fix strong mirror hangings to the back of the frame. To prepare the surface, paint a layer of PVA glue onto the surround. When dry, spread a 6mm (¼in) layer of tile adhesive within the border area. If your mirror is large, do this in stages to prevent the adhesive drying out before you get a chance to position the shells. (The shells should be pressed into wet adhesive.) First, make a grouping of larger shells at the centre of both the top and bottom of the mirror, then fill the edges with smaller shells. Once all the shells are fixed, sprinkle dry silver sand over the frame to cover those areas of adhesive that are still visible. Allow the adhesive to dry overnight, then shake off the excess sand and hang up your mirror.

ROPE TRICKS

Q I have just made a free-standing cabinet for my kitchen using old tea chests (it has double doors and two drawers), but I cannot find suitable door handles. What would you suggest?

Rope is an excellent material to use for handles, particularly the thick, natural coir variety. I would tie a Turk's head knot at the end of a piece of rope, then thread the other end through a drilled hole at the centre of the drawer. Lastly, tie the rope securely at the back. A Turk's head is such a round, fat type of knot that the end result would work much like a drawer pull. You will find other fancy knotting tricks in a scouts' manual. For an even simpler handle, push the ends of the rope through two drilled holes and tie together on the inside of the drawer.

ABSTRACT THOUGHTS

Q I want a big, simple, abstract painting over my mantelpiece. Sadly, the only pictures that have caught my eye have mind-boggling price tags. Any suggestions on how I can create a striking image?

All you need is a ready-stretched artist's canvas that is right for your space – any art supply shop should stock this – then mix a solution of raw umber artists' acrylic colour with water and apply over the canvas with a large brush to create a semi-translucent background. Once dry, place the canvas on the floor over a plastic dust sheet. Then mix up some white acrylic paint to the consistency of single cream. Throw this at the centre of the canvas to create a long streak of paint running from one side to the other. Prop up the canvas so that the paint starts to drip down it. Once the drips are as you like them, lay the canvas flat to dry. I would suggest you then hang the canvas with the drips running upwards in the direction of the ceiling. If your first attempt is a success, you may be inspired to create a series of canvases, each with a different dribbling colour. You could also experiment using several colours in a very large painting.

Homes seem to fall into two categories – those with children and those without – and the difference between them is particularly noticeable where décor is concerned. Walk into a home with white carpets, cream upholstery and pieces of precious glassware arranged at sitting level, and the chances are you are in a child-free zone. Walk into a home with brown carpets, loose covers and a complete lack of ornamentation, and the opposite is probably true. But there is no need for it to be this way. Child-proof homes need not be short on style or alienating to adults. With a little careful planning, it is possible to have children *and* a beautiful home. Admittedly, certain practicalities have to be taken into consideration, but if you ache for a white sofa or a chic open staircase, there will be a way of having one that won't involve banning your toddler from the living areas.

The blissful thing about children in the home is that they are a wonderful excuse for giving vent to all your decorating fantasies. Why else might you create a stencil of dancing fairies, turn an alcove into a tent or go wild with purple? So enjoy it while it lasts and look for ways of keeping all the family happy.

TheFamilyHome

ROUGH AND TUMBLE

Q My wife is six months pregnant and we are trying to redecorate the house before our new baby arrives. We need to put down new flooring throughout and I am keen to have seagrass rather than carpet. My wife is worried that as seagrass is quite rough it isn't suitable for babies, particularly as they start to crawl. Is this true?

If you are set on the idea of seagrass, then do not be dissuaded. Admittedly, it can be a bit like having a vigorous but uninvited foot massage every time you run around barefoot, and your wife's concern for the undercarriage of young babies is certainly an issue. However, our living room was carpeted wall to wall in seagrass when my daughter was little, and she very quickly decided that her feet were far more hardy than her hands and knees – she was toddling by 10 months. So if you really like seagrass, go ahead and put it down. The crawling stage doesn't last long, and you can always cover an area of the floor with a large blanket for baby to play on in the early months.

FIRST STEPS

Q There is an 'open plan' staircase between our sitting and dining room, and I am concerned about making it as safe as possible as we have a three-month-old baby. Can you suggest something that is child friendly but also aesthetically pleasing?

The visual thrill of an open staircase is something that you don't want to lose, but you will need some kind of banister or safety rail for your growing child to hold onto. Safety gates at the top and bottom of the stairs will be a good investment, but you are going to have to install a rail of some kind before you can fix the gates in place. My advice is not to compromise on the modern look. Glass partitions and a steel rail are going to look best, but be warned – they don't come cheap.

BED NOT BORED

Q I read with interest that you used four mismatched newel posts as bedposts for your divan bed. Have you any similar suggestions as to how I might brighten up a child's divan?

Screw a post to each corner of the bed frame. They should each be around 1.5m (5ft) high and 7.5cm (3in) square. Cut eight 25cm (10in) rocket shapes from plywood or MDF (watch *Wallace and Gromit – A Grand Day Out* for inspiration), and then cut slots in each shape so that two pieces will slide together to make a 3D rocket for each bed-post. Cut cross-shaped grooves into

the top of each timber post, deep enough to house the base of each rocket, then glue into the 'launch position' and leave to set. Paint the whole bed in bold colours (not primaries, please) for a bed that will send any child into orbit.

BLISS FOR BABY

Q My sister is eight months pregnant, and I have offered to decorate the new baby's room. Inexpensive, easy ideas please!

Paint the walls in a saffron yellow and then paint the woodwork a warm ivory colour, preferably with an eggshell finish. Next, create a border to run around the walls at dado height. A stylish way to do this is with a display of family photographs, pressed flowers, dried leaves and cut-out pictures laminated in transparent A4 plastic pouches (a photocopy shop will do this for you). To create a shallower border, you could arrange your items so that the sheets can be cut in half either vertically or horizontally. Next, make a large floor cloth, which is a cheap and easy way to create a bold statement. You will need some artists' canvas (cotton duck), a plastic dust sheet to protect your work surface and some contact adhesive. Cut the canvas to size, fold in all edges about 6–8cm (2¼–3in) and glue them to create a hem. Prime with a base coat of emulsion, then use emulsion paints and acrylic artists' colours to decorate in a bold, simple pattern. If you feel artistically challenged, simply mark a grid and paint the squares as bold as you dare in a checkerboard pattern. Seal the design with two to three coats of acrylic varnish.

WHITE'S ALL RIGHT

Q Am I completely mad to be considering buying a white sofa?

Not necessarily – just make sure the sofa has loose covers that not only are machine-washable but also have received a guaranteed, stain-resistant treatment. However, before you hand over the credit card, exercise a little caution in the shop and insist on removing the covers to make sure that they aren't too tight. A generous fitting will make replacing the washed covers much easier.

GROWING ROOM

Q We have just moved into a house where the kitchen has been extended with a conservatory. The last owners used the conservatory as a dining area, but I want to turn it into a playroom for our toddlers. Do you have any suggestions for furniture and flooring, and also some means of separating the area from the rest of the kitchen?

Almost any wooden flooring would be perfect – it is resistant to sticky fingers, paints and general childish mayhem, and can also be scrubbed up to look elegant if you decide to use the room for more grown-up purposes. If you choose solid wood rather than laminate, make sure that it is thoroughly sanded and sealed with at least three coats of varnish to avoid the possibility of splinters. As for seating in a children's room, I would use lots of foam cubes upholstered in brightly coloured canvas that can be used either as building blocks, seating or tables. If you design them carefully, they can also be used to build a screen when you want to separate the conservatory from the kitchen.

CAMPING IN

Q I love the idea of turning the alcove in my 10-year-old daughter's bedroom into a tented fabric cupboard. How should I proceed?

The first thing you must do is fit a hanging rail inside the alcove plus any shelves for storing books and toys. Then the fun begins: screw appropriate lengths of 5 x 2.5cm (2 x 1in) timber battens horizontally around all three walls of the alcove about 60cm (24in) below the ceiling. Line up a fourth batten with the three you have just attached and screw it into place across the front of the alcove. In effect, you have made a horizontal frame, which will provide you with mounting points for the fabric screen and a base for the tented top. Now screw in two more battens vertically down the inside face of both side walls so that they are flush with the front edge of the alcove.

Now for the fabric: use a piece of heavy cotton canvas to create the screen front. Cut and hem this to fit the full length and width of the alcove from the front batten which lies across the alcove to the floor. Decorate the canvas with fabric paint colours in a design of your choice. Next, screw some evenly spaced cup hooks into the front batten and sew some correspondingly spaced eyelets into the upper edge of the canvas. To fix the fabric screen in place, sew, glue, tack or staple the rough side of a strip of Velcro onto the front face of both vertical battens. Stitch the other side of the Velcro down each

side of the canvas screen. Then hang the screen on the cup hooks and press the Velcro closed at both sides.

To make the roof for the tented top, cut four triangular roof sections from corrugated cardboard (measure the lengths of the four horizontal battens to give you an accurate guide). Fasten these together with tape, and check how they fit and look once you have placed them on top of the battens. Adapt the triangles to fit neatly into the available space. Once you are happy with the structure (you may have to cut a fresh set using the others as a pattern), glue canvas over the cardboard and decorate the canvas with fabric colours as before. You can then hand-stitch the four sections together and place the tented roof onto the batten frame. To hold it secure, stitch ribbons to each corner of the tent top and tack the ribbon tails to the battens. If you are feeling adventurous, you can always go out and create a Punch and Judy-style, multi-peaked roof.

NO MESSING

Q We live in a very small house, and during the day our sitting room doubles as a nursery. I have noticed that our coffee table is getting badly damaged but it is too heavy to move. How can I protect it from my rowdy twins?

It sounds as though the sticky fingermarks and melted chocolate might be getting the better of you. If it is a quick and easy cover-up you need, then a length of plasticized cotton fabric would do the trick. It's available in so many patterns and colours that I have even seen it covering quite respectable restaurant tables – presumably for adults who can make just as much mess as your children. Alternatively, you can make a more permanent covering with vinyl floor tiles. Turn the tiles over so that they are lying upside down (make sure that they are butting together, not overlapping). Trim the sides to fit the top, and tape them together with strong carpet tape or photographers' gaffer tape.

FAIRY FANTASY

Q How can I create a stencil of silhouetted dancing fairies for my children's bedroom?

Look for fairy images in children's books and select at least seven fairies in different cavorting postures; ideally, they should be in profile. Trace the outline of each figure and enlarge them on a photocopier, aiming for figures that are at least 30cm (12in) high. Use a light coating of repositioning adhesive to secure the copies to a piece of stencil card, and cut around each one with a sharp craft blade. Build up a frieze around the wall with the stencils, using a mid-grey acrylic paint instead of black, as it creates a softer effect. To achieve a delicate gossamer look, simply outline some of the fairy wings with grey, rather than filling them in with colour.

FLOOR PLAN

Q We are renovating our house on a tight budget. As we have three children under the age of ten, what is the most practical flooring in well-trodden areas such as the hallway?

The practical option is to have exposed wood. This will be by far the most durable surface and need not be too costly. If your existing floorboards are in reasonable condition, then strip them down and stain or paint them. If you opt for a stain, make sure you finish the boards with at least three coats of matt or satin floor varnish. However, if the boards are in bad condition, you will have to paint them. You could try your hand at creating a checkerboard effect of black and ivory squares. Use a really tough floor paint and finish it off with a coat of varnish for extra durability.

GOOD CLEAN FUN

Q I want to decorate our children's bathroom. I thought it might be an excuse for something bold and imaginative.
Any suggestions?

Lucky you! There is nothing better than the opportunity to go completely wild in a bathroom. The possibilities are endless, but it is better to go for something timeless, such as a desert island or pirate ship, rather than a Disney theme – children have the habit of going off them. Find some suitable images in a children's story book. Draw corresponding grids on the picture and wall in order to recreate the scene in the correct proportion. It is easier than it sounds, and if you make a mistake you can always paint over it. Use any paint you like and seal the surface afterwards with a coat of acrylic varnish. For the flooring, don't use carpet or seagrass – vinyl or lino are the only practical options.

DEN OF DELIGHTS

Q I would like to convert my tiny garden shed into a Wendy house for my two young children. Do you have any suggestions for the décor?

Colour the wood with something vivid – a bold blue would be great in a garden. Some of the new, external timber paints can be used over creosote (or similar wood preservative), so preparation of the timber should be minimal. If you do choose blue for the colour scheme, paint the outside first and the inside in a paler tone of the same colour or a creamy white. If you have any spare carpet or vinyl, put it on the floor to make it more comfortable. Fix galvanized steel boxes under the windows and cultivate fast-growing plants or vegetables, such as runner beans, broad beans, tomatoes or lettuces. Blue gingham curtains and a white picket fence would make the perfect finishing touches.

READY, STEADY, PLAY!

Q We are thinking of converting our garage into a playroom for our three daughters. Do you have any tips on how we should go about it? We are considering tongue-and-groove on the walls.

Insulation should be uppermost in your minds; wall cladding is an excellent idea as you can put thick insulating materials behind it. If possible, you should also insulate the roof and lay a wooden floor. I would split the room into two levels; a third of it should be raised by about 30cm (12in). This will create two separate areas and provide a stage for budding performers. The lower area could have built-in foam seating. Fix thick sheets of foam at back height around one corner of the room, then upholster them using a hard-wearing cotton fabric and a staple gun (use rope and a glue gun to cover the staples). To make the base, cover blocks of foam in the same fabric. Add decorated floor cushions and a colourful rug. Using secure, heavy industrial fittings, hang climbing ropes and/or rope ladders from the ceiling joists, and add crash mats below. Finally, throw in sleeping bags, as your daughters will never want to leave their cool den.

PURPLE DAZE

Q My 11-year-old daughter wants her bedroom to be painted purple. What other colours can I use for woodwork and window frames? I am worried how such a strong colour will look in a bedroom.

Why not go for the Seventies look, which is so fashionable at the moment? Purple and green work a treat together. Then add some plain black picture frames, and dye the bedlinen black using a machine-wash formula. This will offset the room's lurid colours. Choose a duvet carefully: look for one with a large, bold pattern, preferably something with a strong retro feel about it. You could even throw in a beanbag or two, and give your daughter a lava lamp for her birthday. She will not be able to believe her luck . . . or her eyes.

FULL OF BEANS

Q Have you any ideas for making a beanbag for my 15-year-old son?

Beanbags are enjoying a revival and they can look fantastic. I would use a good camouflage fabric and make a simple cube. Pack it with a plain cotton lining bag of a similar shape, which can be filled with polystyrene balls (available from most good department stores). If in the end you decide to buy, then the most sought-after bags currently are those made from suede or rubberized cotton.

TEENAGE KICKS

Q I am 15 and have been allowed to redecorate my bedroom. The room is quite dark, as it has only a north-facing, Georgian-style window. I have no idea where to start. Can you help?

It would be fun to use a different colour for each of the walls. It sounds radical but will work if each colour has the same tone. For example, a combination of magenta, blue, purple and silver would create the perfect colour scheme. Once you have painted the silver wall, frame it with a border that is the same colour as the opposite wall. You could also consider buying a platform bed that leaves plenty of space on the floor for silver beanbags and a low table. Add a stack of aluminium storage boxes, and cover the window with a simple roller blind – but use black-out fabric if you are a person who likes to slumber until midday.

Who would have thought in this age of technology that people would have so much fun taking up craftsmen's skills, and making their own furniture and fittings? It's not so much a question of saving money as the fact that each piece can be custom built to your own needs and specifications, whether it's an island unit for the kitchen or a console table for the living room.

Salvage is a key word here. This section is not a conventional look at how to make a bed or a bath surround. The ingenuity lies in using unexpected materials to spectacular effect – ways of utilizing anything and everything, from boxes and broken china to copper tubing and slabs of concrete. This is perfectly in tune with the path that contemporary design is now taking, where furniture-makers are as excited by the textural as the structural possibilities of combining glass with stone, or wood with steel. This chapter will open your eyes to simple ways of achieving such exciting combinations for yourself.

Don't worry if you are not a skilled DIY person. Making furniture need not be complicated, just find a simple project to cut your teeth on and soon your confidence will know no bounds.

Furniture&Fittings

TABLE TALK

Q I seem to have scoured the country for an attractive coffee table. So far my search has been in vain. I don't want anything that is reproduction, ethnic or metal, and I refuse to give up my search. Please help.

Have you thought of making your own? A visit to a salvage yard should uncover a number of possibilities for table supports such as broken pieces of carved stone or sections of wooden carving. Tell staff at the yard what you are looking for and let them do the thinking. They will know the stock better than anyone, and the bits of stone that are perfect for the job will invariably be hidden under years of accumulated debris. Depending on the size of your finds, you will need either two or four supports of equal height. A glass top is a good idea, as you will still see the supports once the top is in place. Other options for a table top include salvaged timber or a piece of weathered mirror glass, but make sure that the edges are polished and smooth.

IRON RESOLVE

Q Do you have any suggestions as to how I could make my own iron bedside table?

Try making use of old cast-iron grilles, which are often on sale in reclamation yards. They might look like useless chunks of metal, but they can easily be transformed into very chic bedside tables without too much effort. Choose a grille or a combination of several that give you the table-top size you need. Then use your phone book to locate your local welder. Ask him or her to bond smaller grilles together to make one large piece suitable for a table top, and then add on some steel rods for the legs. After 10 minutes of spot welding you will have a very sturdy little table. Allow each leg to project proud of the table top by 1cm (⅜in) in each corner to retain the glass, then drop in a piece of safety glass that has had each corner rounded off by the glazier.

CLASSY CONSOLE

Q I am looking for a console table to place between my 1.8m (6ft) long sofa and a bay window. I cannot find one the right size, so I thought I might make my own. How should I go about it?

Use a thick piece of timber or MDF to make the top of the table. Put it on the floor and draw a line around it with chalk. Remove the top, prime it and leave it to dry. Now use the chalk to draw an S-shaped curve that fills the marked area, and use this as a plan on which to build a support made from glass bricks. You will need to fix the bricks together using a white mortar mix that is available from most builders' merchants. Once you have reached the required height, use a little more of the mortar mix to secure the top to the bricks. The top can be painted with emulsion and varnished. If you are feeling very creative, a painted *faux* stone finish would look great.

MOSAIC MARVEL

Q I have a lot of broken china. How might I go about using it to decorate the top of a table?

Place all the china in a thick, see-through plastic bag and use a hammer to tap it into smaller pieces that are flat enough to create a smooth surface. The table could be something you have found in a junk shop, or one that you want to give a new look. Create a lip around the edge of the table top using strips of wooden moulding. Mitre or butt the edges neatly and use panel pins to secure. Apply a 6mm (¼in) bed of pale grey tile adhesive over the surface, starting from the middle of the table top. Press the china pieces into this randomly or, to build up a pattern, score an outline into the wet cement and fill with tesserae of one colour. Butt the tesserae pieces closely and continue until the top is finished before gently wiping the surface clean using a damp cloth. Allow to dry overnight, and wipe the surface again until it is completely clean.

TABLE DISPLAY

Q I have painted a simple side table that I found in a junk shop and I would like to decorate the top. Do you have any inspired ideas?

Assuming that the table is square or rectangular, I would build up the edges of the table top with strips of timber 2.5cm (1in) high by 1cm (⅜in) wide to create a shallow box. Paint the new timber to match the table. Once it is dry, create a display of objects in the box, such as seed heads, feathers, documents and photographs, or a combination of all these things. Finish off with a piece of toughened glass that fits over the top of the table. Use metal fixings on all four corners to hold the glass securely.

BOX CLEVER

Q I am short of storage in my sitting room and would like to make a coffee table out of a collection of boxes. How should I go about it?

There are plenty of good-looking storage boxes on the high street. Find some that are intended to be used for filing – the sturdier the better. Buy four boxes and arrange them on their sides to create a rectangle. Cut a piece of 12mm (½in) MDF to the exact dimensions of the four boxes, and screw a castor to each corner. Place the boxes on top of the base, and cut another piece of 12mm (½in) MDF about 20cm (8in) wider to make a coffee table top that slightly overhangs them. Stain both top and bottom a rich chocolate brown, and seal with three coats of acrylic varnish. Secure the top and bottom to the boxes with sticky pads.

TOP TABLE

Q We recently had to demolish an old outhouse, but I managed to salvage its beautiful door. I now want to turn it into a dining-room table; however, I do not have very good carpentry skills. What could I do with it?

You need to look for a table without a top or one that could easily be removed. Try to find an old farmhouse kitchen table with chunky timber legs. Strip back any old paint layers, then recondition the wood with a rich furniture wax. Drop your old door in place and secure it from underneath with screws. If the door has intricate moulding details, you could add a top that is made from safety glass.

PLATFORM SNOOZE

Q Having bought a studio flat six months ago, I am still sleeping on a mattress on the floor. I am trying to avoid the usual sofa-bed/futon option. Are there any alternatives?

Try and get hold of six wooden pallets. Scrub and lightly sand them before tying them together to create an oversized platform for a bed. Cover the top of the platform with sheets of hardboard or MDF (use panel pins to secure these), or just pop the mattress straight onto the pallets. The platform will extend generously around three sides of the mattress, leaving plenty of space for books and other paraphernalia.

Tip

Day beds, which are a cross between a bed and a sofa, are very fashionable at the moment. Those in the shops tend to be quite expensive, but it is easy to make your own. Ask a carpenter to make you a simple wooden frame to fit your mattress. The framework should include a shallow back rest and equally shallow side supports. Make two long, cylindrical bolster cushions for the back and two shorter bolsters for the sides. I would also make a matching mattress cover. The result will be a seriously stylish piece of furniture.

VANITY REVAMP

Q I am doing up my bathroom which has a vanity unit with hideous Melamine doors. I have seen a photograph of a basin with a curtain hanging beneath it. How do I go about replicating this idea?

If I am honest, I have to say that I find 'curtain cupboards' a bit fussy. There is an alternative that would fulfil the same function but is far more contemporary in style. Rather than hanging a curtain, make a folding screen from a series of rectangular pine panels covered with either punched sheet metal or tightly fitted muslin. Join the panels top and bottom with hinges, and fix one end of the screen to the frame using another pair of hinges. To access the cupboard, simply fold the screen to one side.

ON THE SLIDE

Q We have mirrored sliding doors on the fitted cupboards in our bedroom. Not only do they come off their 'slides' but also they look ugly and dated. Can you suggest an inexpensive alternative?

Repair and utilize the runner system, only this time replace the mirror doors with lighter, timber-framed screens. Think Modern Oriental rather than Seventies Suburbia. Each screen must be exactly the same dimensions as the original doors so that they run successfully on the old tracks. If you are not absolutely sure that you can make the screen frames well, hire a good carpenter for the day. I would choose a pebble-coloured, lightweight fabric to cover the screens. Measure the fabric accurately to fit, remembering to add enough to wrap around the edges of each screen. Then all you need do is glue the fabric onto the screens using a white PVA adhesive.

THE BIG SCREEN

Q We have a large, grey, stone fireplace in our sitting room, which I would like to lighten in some way. Any ideas?

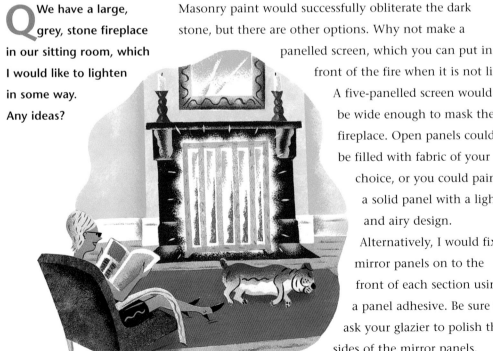

Masonry paint would successfully obliterate the dark stone, but there are other options. Why not make a panelled screen, which you can put in front of the fire when it is not lit? A five-panelled screen would be wide enough to mask the fireplace. Open panels could be filled with fabric of your choice, or you could paint a solid panel with a light and airy design. Alternatively, I would fix mirror panels on to the front of each section using a panel adhesive. Be sure to ask your glazier to polish the sides of the mirror panels.

MODERN MANTEL

Q We have just ripped out a horrible Thirties fireplace surround and my husband is keen to make a replacement. Ideally, we would like a surround that is traditional in form but with a contemporary feel.

If the inner fireplace itself is in good repair, then you can proceed with the fire surround. If, however, the inner fireplace needs repair, replace the firebricks and mortar first. At this stage, you can decide whether or not to render the area around the fireplace so that you don't see any brickwork. Choose a hearth (my favourite material would be dark slate) and a traditional iron grate, then make a 'box' surround that is low and wide in proportion, and includes display niches on either side. Use 5cm (2in) timber battens and fireproof MDF to build the three box sections that will fit together to make the top and the sides. The side sections should consist of three niche 'boxes' on top of one another, each about 20cm (8in) deep. The top should be built as a shallow box. The proportions will depend on the size of your chimney breast. However, the inner edge of the surround must lie at least 15cm (6in) away from the edges of the fireplace. Screw the sections onto the chimney breast, then fill and sand all screw holes and any uneven joins in the MDF. Prime and paint with a flat colour that fits in with the rest of the sitting room. Finally, screw strips of chromed-metal edging around the three sides of the fire surround nearest the fireplace to protect it from scorching.

Tip

If you want to make a curved piece of furniture, the best material to use is Flexiply – it's fantastic to work with. You are more likely to find it at a timber merchant's than at a DIY store.

LONG DIVISION

Q How can I make a triptych-type screen that I can cover in a collage of photographs and newspaper cuttings to use as a room divider?

Once you have three pieces of MDF cut to size, join them with screen hinges and paint the panels with an emulsion base coat. Fix the cuttings with spray adhesive and then seal the prints with at least two coats of any acrylic varnish.

RADIATING CHARM

Q In my hallway I have two radiators facing each other. I do not like conventional radiator covers and I wondered if you had any suggestions for something that will conceal the radiators and at the same time provide some kind of shelf?

Modern flat-fronted radiators can look very ugly, but there are plenty of ways of disguising them. First, put up an ordinary pine shelf, about 5cm (2in) away from the top of the radiator, then spray an inexpensive, beaded fly curtain in a colour of your choice. Staple or nail the painted curtain along the underside of the shelf to cover the radiator, and trim it to the right length. Alternatively, lengths of chain or a panel of semi-transparent gauze or muslin could be used to cover the radiator.

Tip

Be imaginative when replacing bath panels – the stunning, pierced wooden screens in Indian palaces are very inspiring. You will have to box around the bath in the conventional way, but use a fretwork panel to run the length of the tub. Because you will be able to see through the fretwork, you could paint the bath a contrasting colour. Or even better, silver gild the side so that it shimmers.

SURROUND YOURSELF

Q I am currently doing up my bathroom. The pressed-steel bath isn't free standing, so I will have to box it in. Most ready-made bath surrounds seem to be rather tacky. Can you suggest an alternative that is both practical and chic?

Make your own panel with a sheet of 9mm (⅜in) MDF. You will need to secure the MDF to a timber framework around the bath. Then ask a glazier to cut long thin mirrors that you can attach vertically to the sides. Each strip should be around 15cm (6in) wide – you will need approximately seven strips for the long side of the bath and three for the end. Mark the positions of the mirrors on the MDF and hold them in place with panel or mirror adhesive. Use narrow strips of decorative moulding with mitred corners to frame the mirrors (secure them with panel adhesive). Finally, paint the moulding and exposed MDF in the colour of your choice.

TOPICAL ISLAND

Q We have a large farmhouse-style kitchen. I plan to divide it into two areas – one for dining and the other for cooking. However, I would like a degree of flexibility. My husband has suggested that we make an island unit on wheels. Is this practical and how should we go about it?

A central island unit has been the most practical and regularly used surface in my own kitchen. If you build a fixed unit it is possible to incorporate kitchen appliances – just make sure that the services are plumbed and wired into the central area before any other carpentry and installation work goes ahead. As an addition to an existing kitchen, a mobile unit can offer the most practical solution. Fix castors to the legs of a large butcher's block or an old timber table. Shelves, wine racks or cupboards offer useful storage underneath, although you will have to work carefully with the original structure so that the new shelving doesn't look out of place.

ON THE EDGE

Q Can you tell me how to make self-supporting shelves?

Use a chunk of reclaimed timber or roof joist to create shelves that seem to defy gravity and 'float' in mid-air on the wall. They are surprisingly easy to construct. First, cut your shelves (which should be at least 5cm [2in] deep) to the required length. Then cut from each shelf a 2.5cm (1in) square strip of wood the length of the shelf. These square strips will in fact become the wall-mounting battens for the shelves. Screw each one securely to the wall, then replace each shelf over its corresponding batten and fix it into position with long screws by screwing down from the top at regular intervals. (This means you no longer see the batten.) Of course, if you choose a large, chunky piece of wood to create heavy-duty, rustic-looking shelves, you must use a far bigger batten, one that is at least 5cm (2in) square.

PIPE SCHEMES

Q I love the higgledy-piggledy kitchen in my cottage, but there is very little space. How can I create extra storage?

Wall-mounted rails are very good for storing all sorts of kitchen implements, such as pans, strainers and colanders. All you need is a length of copper tubing from the plumbing section of your local DIY store, some wardrobe rail brackets (three for each length of rail) and a pipe-cutter. Spray the pipe with a clear lacquer or varnish, then cut it into appropriate lengths. Support each rail against the wall using the brackets, then hang your implements from S-shaped butchers' hooks.

Today it's not enough to own something – you have to know how to maintain it as well. Continually replacing furnishings that are less than perfect is a wasteful way of living – and too expensive an approach for most of us. Instead, it is worth learning a few clever tips that will hold you in good stead should you burn the kitchen worktop, stain a stone surface, or discover woodworm in a much-loved family heirloom.

There is also increasing interest in the craft of renovation. The humblest objects can take on new life and elegance when restored to their former glory. Just think about the feel of lacquered leather or the creaminess of marble, and how wonderful it is to take something tarnished and invest time in making it beautiful once again. There is advice here, too, on giving facelifts to existing features and fittings that might otherwise look drab and tired.

Apply some of this practical knowledge next time you are rummaging around junk shops searching for that 'something' which might look perfect in your home. After all, even the most unpromising raw material can be transformed into a truly covetable item with a little bit of expert know-how.

Renovation&Repair

OFF YOUR MARKS

Q There are several rings and marks on my marble-top table and it is impossible to tell if the marble was ever sealed. Do you have any ideas for removing them?

Try using a pH neutral soap. This should work if the marble has been sealed. If the stain is below the sealant, the only way to get rid of it is to strip away the marble surface, reseal and polish it – a hefty job and not for the faint-hearted. Alternatively, you could disguise the marks. I would 'frost' a piece of clear safety glass that has been cut to cover the table top.

SURFACE ATTENTION

Q My kitchen worktop, which is veneered in plastic, has a small burn hole in it. Is there anything I can do to repair it?

Take a knife to the damaged area and cut away the burn mark plus a little bit of the underlying surface, which will probably be chipboard. Clean the hole, making sure there are no dust particles, and fill with a generous dollop of wood filler. It's always best to overfill the hole slightly, allowing the filler to rise above the surface. Leave the filler to dry, then sand it smooth with a fine sandpaper. Next comes the artistic bit: mix some acrylic colours together to match the veneer, and apply with an artist's brush. When it has dried, cover the area with varnish.

STONY-FACED

Q We have York stone on our kitchen floor. Every tiny drop of something fatty marks it indelibly, so that it looks a mess. I have had it professionally scrubbed and sealed twice but without improvement. What else can I try?

Scrubbing then sealing is a treatment that all stone specialists recommend. The problem could be that the type of product used to treat your floor was inappropriate; to find the best one, the cleaning companies you hired should have test-treated a small area before they did the whole floor. If the stone floor has a rough surface, this could have exacerbated the problem, as it would have been more difficult to treat or seal the floor effectively. I hate to be the bearer of bad news, but it does sound as if the fatty marks got into the stone before it was treated. If this was the case, then I'm afraid the marks will probably never come out.

Repairing damage caused by fat marks, burns or water staining on natural surfaces such as stone or wood invariably means a powerful sanding-back to the surface below the level of damage. You must then re-treat the undamaged surface to protect and seal it, using the best products you can afford. Maintenance is the key. For continuous protection you will need to apply the correct treatment products regularly; how often, though, will depend on the wear the surface receives. For example, a beech work surface next to a sink will require treating with tung oil every week, while the same surface away from water may only require oiling once every six months.

STAIN-RESISTANT

Q There is a stain on my bathroom ceiling that I can't get rid of, even though I have painted it with a stain barrier. What do you suggest I do?

You will have to get tough. For plasterboard ceilings, this may mean chopping out the offending patch and replacing it with new materials. You should then cover the whole area with a glass-fibre sheet and a suitable bonding. You can then paint over the sheet using your usual paint.

DAMPENING SPIRITS

Q One of the walls in my bedroom has a damp patch that is about 1m (1yd) square and wallpaper will not stick to it. The wall faces the outside. What should I do before I decorate?

You need to hack away all the damp plaster and then reapply some more. Wait until that is dry, then decorate. This will resolve the immediate problem of the damp area, but you should make a few checks to identify the cause of the moisture before investing any serious time or money in redecorating. The underlying problem could still remain, ready to reappear as soon as you've finished painting or wallpapering. It might be a problem that could be easily resolved. Check the condition of your window-sills, as rainwater could be seeping through rotten woodwork, or maybe there's nothing more than a crack in the brickwork.

WINDOW TREATMENT

Q The window in the bathroom of my new flat was very badly installed and is horribly crooked. It drives me to distraction. How can I make it look straight without having to refit the entire window?

You will need to fix wooden battens around all four sides, using a spirit level to keep the edges straight. Use this as a frame on which you could hang either American-style shutters, wooden slatted blinds or a Roman blind made from a semi-transparent fabric. If there is a sill beneath the window, this may need to be sawn back to become flush with the battens. Alternatively, allow the timber surround to project forward enough to lie level with the sill. The blind you choose can be kept lowered so that everything will appear square while still allowing in natural light. Otherwise, you could forget the blinds and create a dramatic effect by fixing lengths of gilded picture frame to the four battens around the window.

WORM TURNING

Q There is a patch of woodworm on my dining-room dresser. How can I prevent it from spreading, and how can I treat the affected area?

These tyrants have done their damage by the time you notice the tell-tale holes. If the attack is still going on, there will be light-coloured dust around the holes, but it can be difficult to detect. I would give the furniture a good clean, then treat it with woodworm treatment fluid (obtainable from most DIY shops). If you see other signs of infestation, you should call in a specialist.

SPOT CHECK

Q I have a new tiled floor in my kitchen, which is in good condition except for the grouting. As it is porous, it is becoming marked with grease spots. I do wash the floor regularly but the grease doesn't come out. How can I overcome this? I cannot be the only one with this problem.

The best way to avoid this problem occurring is to use a grout sealer, but as the damage has already been done, you will need a specialist cleaning material (a tile manufacturer's help line should be able to assist). Unfortunately, there is a chance that the marks are too deep for any type of remedial treatment to be effective. If this is the case, you should rake out the old grout and replace it. In either case, you should remember to seal the grout – prevention is so much less hassle than cure!

POLISHED STORY

Q I have a Chinese wedding chest made from lacquered leather, which is now chipped in many places. This has revealed spots of white undercoating, which I would now like to repair. A friend has suggested ox-blood shoe polish. Is this a good idea?

Shoe polish can be a great product to use for repairing lacquered leather, provided the colour is a perfect match, otherwise you may notice the difference. You can tint the polish using artists' oil paints mixed with clear furniture wax (about a 2cm [¾in] squeeze of paint to a tablespoon of wax). You may have to blend a few colours together to get an exact match for the old leather. Rub the tinted wax into the chipped areas and then buff to a soft sheen once it has dried. (This can take up to 24 hours.)

> **Tip**
>
> To restore the lustre of Bakelite, use a dusting cloth to gently rub some beeswax into the areas that need restoring. Leave the wax for a couple of minutes, and then buff both the newly waxed areas and the rest of the item. This should bring back the soft sheen, and at the same time it will improve the overall finish.

WHITE ON WHITE

Q My fridge and freezer are kept in the garage, and the enamel finish on both is showing signs of rust. What can I do to eliminate the rust and then refinish the surface?

It is possible to prevent the rust creeping even further over your white goods if you use a good enamel spray, available in cans in most DIY stores. (Be sure it is a kitchen enamel.) However, you will have to put in a bit of hard work first, as all that rust has to be brushed away back to the bare base metal before you can apply a new coat of paint. The best way of doing this is to use a power drill with a wire brush attachment. Once all the rust and old paint has been consigned to the garage floor, you can spray on the enamel. Build up several light and even coats rather than putting on one heavy coat, as a heavy hand is always a recipe for paint runs.

> **Tip**
>
> If you have exposed copper radiator pipes running through your living areas, avoid painting them with emulsion, tempting though it may be when you are repainting your walls. In time the emulsion will peel and you will be left with the arduous task of stripping it all off. Rather, use an enamel paint suitable for radiators. That will stay put no matter how hot the pipes get. Working only when the pipes are cold, first paint on a good metal primer. When dry, apply one or two coats of enamel. Allow to dry – then turn up the heat.

GO WITH THE GRAIN

Q I have a pine wardrobe that I want to use as a linen press. Sadly, because the wood has never been varnished or waxed, it has taken on rather a nasty orange colour. How can I disguise the colour without losing the character of the wood?

I would stain it with a delicate colour that suits the room in which it is to stand. Wearing rubber gloves and using a pad of wire wool, scrub the surface of the wardrobe with white spirit. This should remove most of the orange colour. Allow the wood to dry before sanding it in the direction of the grain, then coat it with your chosen stain. There are a growing number of excellent woodstains on the market, and these will darken the colour of the wood without obscuring either its grain or its patina. The result will be more like a rich hardwood such as mahogany or wenge, but at a fraction of the price. It is also possible to use more than one stain and to build up layers of colour. For example, you could use pale grey as an undercoat and then add a layer of darker grey to create a look that is more French château than Swedish palace. If you have the time and inclination, finish with plenty of beeswax applied with wire wool. This will require a lot of elbow grease, but you will be rewarded, as it will enhance the grain and give a fabulous sensual finish. You could also drill the doors with 1cm (⅜in) holes in a grid or circular pattern. This will allow air to circulate and create an attractive feature. Paint the interior off-white, adding extra shelves if you need them. Pewter-coloured handles would provide the perfect finishing touch.

PERFECT FINISH

Q I have a light oak, fitted kitchen and would like to alter the finish to one of limed oak. Is this possible?

Yes, if you strip back to the protective factory finish using a gel type of stripper. (You may find it easier to remove the doors first, but remember to mark them and the carcasses with a code to make refitting easier.) Other areas need to be treated *in situ*, so leave the windows and doors open for ventilation. Next, raise the grain slightly by rubbing a wire brush over the surface. Then apply an appropriate woodstain for a translucent matt finish to seal, protect and colour the surface.

PANEL GAMES

Q We have some fitted cupboards in our bedroom that look somewhat jaded. What do you think we could do to update their outside appearance without going to great expense?

If the doors are made from solid timber, I would suggest that you remove them and cut an open panel into the centre of each door using a jigsaw. Then buy some fretwork panels and, using panel pins, fit a glazing bar (it looks like a slim wooden batten) around the inside edges of each of the openings. You can secure the new fretwork panels to the glazing bars with more panel pins. Finally, add a strip of decorative moulding around the front edges of each opening to disguise the join between the panel and door surround. The doors should be painted before being rehung. To complete your new look, add some handsome new handles.

TAKING A SHINE

Q I have a very tatty old tin trunk that I want to restore and use as a low table in my sitting room. Do you have any suggestions as to how I should go about it?

I would burnish the trunk using a steel-wire brush attachment fitted to a power drill (you can find them at most DIY stores). The fast-moving wires on the brush attachment will spray debris in all directions, so it is essential to protect your eyes with goggles. Carefully work over each surface, and aim to remove every scrap of paint or rust. You will be left with a wonderful, shiny metallic surface. To stop it becoming tarnished, spray the surface with at least two layers of glass lacquer.

IN THE FRAME

Q I have the wooden framework for a three-part screen which was once covered with fabric. I am no great needleworker, so can you suggest an easy way to transform it?

Putting fabric back onto the screen should be easy and need not require any sewing. Take your fabric and staple it to the screen at the back of each panel. If you don't have a staple gun, use tacks and a hammer. Pull the fabric taut, working from the centre of each side first, then stapling out towards each corner. Once the stapling is complete, trim away the excess fabric, and cover the line of staples with glued and tacked-on strips of wooden decorative moulding; then paint these to match the rest of the screen framework.

Tip

Renovation needn't be all about antiques and French polishing. It is rewarding to see any piece of furniture transformed from the decrepit to the divine. Check out your local junk and charity shops for bargains. Start at the £5 level to build up confidence and experience, then progress from there.

CABINET RESHUFFLE

Q My pressed-steel shower cabinet needs a facelift. The previous coat of rust-preventing paint is peeling, even though the cabinet itself is sound and rust free. Is it economical to tile the interior or would it be better to try another finish?

I would steer clear of tiling a steel shower cabinet, because any movement in the structure, such as stepping into the shower, would have newly laid tiles dropping off the walls before you can say 'grout'. I think what you already have is the best option. Scrape away any peeling paint and start again with a new finish. Rather than recoating with paint, use a spray enamel and the necessary primer beforehand.

STRIPPED ASSET

Q Is it possible to remove a layer of paint from a cast-iron fire surround? Or is it better to paint it black?

Using paint stripper can be a messy business but it is probably the best means of attack in this situation, as the paint may have been laid on thick. Once the stripper has removed most of the paint, put on goggles and fix a metal brush to a power drill to buff the surface until it has a wonderful shiny lustre. This can be a very attractive finish, especially if the surround is made from stone or old timber.

Gardens have become vital to our quality of life in recent years, and they are now considered an extension of the home. As land becomes scarcer and properties are built smaller, it makes perfect sense to exploit every piece of available space, including any outdoor area.

But there is much more to it than that. Increasing numbers of people are discovering the joys of gardening and the pleasure that can be derived from living out of doors – as much as the weather permits. We now cook in the garden, hold parties in the garden and take every opportunity to relax in it. It therefore follows that gardens should reflect our characters as much as our homes do, so it is only sensible to spend some time and energy making our outdoor areas as attractive as our interiors. As with a room, this means thinking about everything, from structure and colour to furniture and accessories.

This isn't a gardening book, however, so you won't find planting advice here, or tips on how to dig a pond. But what you will find are plenty of workable ideas for everything from brightening up brickwork and renovating garden furniture to making window boxes and designing your own garden lights.

TheOutdoorRoom

OUTER SPACE

Q I have a terrace house that has what estate agents call a 'return' – a long, thin space between our house and the next-door neighbour's. As our garden is very small I would like to make the most of the space. Our neighbour has turned hers into a greenhouse, but I fear that if we did the same we would block out light from our kitchen and living room. Do you have any suggestions as to how this area can best be used?

You're right – this is the most perfect site for a greenhouse or conservatory. So often this space is wasted and ends up as a dumping ground for garden furniture and tools. However, it is an area that is difficult to utilize without involving an architect and some builders. But if money is tight, you could consider constructing a pergola that would extend from the doorway to the end of the passage. Good planting could include jasmine, clematis and passion flower, which would provide interest, colour and fragrance all year round. Another good idea is to paint the exterior walls white, because this will help to dispel the gloom.

PEBBLES WITH DASH

Q In the space between my outside porch door and the inner front door, the floor has been finished with a layer of concrete measuring about 1 x 1.5m (3 x 5ft). The porch is made from glass and wood, and benefits from a lot of light. What type of finish would you suggest?

Concrete floors are a real treat for an adventurous decorator. A traditional approach would be to paint fake tiles or floorboards. Alternatively, you could create a pebble mosaic to cover either the sides of the porch floor or the whole of it, if you think you could live with the uneven finish. Embed the pebbles in a layer of quick-set cement, working on one section at a time. If you have pebbles in two colours, you could create a simple square or diamond shape. Choose pebbles of uniform size to avoid excessive lumps and bumps.

HARD CHOICE

Q I want to create an area where we can eat outside in the summer. I hate concrete slabs and crazy paving, but I believe brickwork can be tricky to lay, and real stone is expensive. Can you suggest an attractive, affordable alternative?

There are several things well worth considering. The first is made of natural materials, it requires very little maintenance and if you get the right stuff it comes with a lifetime guarantee. Interested? It's decking: stylish, very good looking and all the rage on penthouse terraces in New York. A quicker solution would be to spread a thick layer of gravel over concrete, making sure that the perimeter is contained by some form of border so that the gravel chips don't spill out. Most builders' centres offer a delivery service, which you'll need as it takes a serious quantity of gravel to cover a patio. If neither of these ideas inspires you, you could try a bit of DIY pebble mosaic. The results can look stunning and pebbles are easy to find in all sorts of shapes, sizes, colours and textures from most garden centres. As with all mosaic work, you will need a lot of time and patience rather than large amounts of cash. I would plot out the design on paper first, remembering that simple geometric patterns will be the most effective.

IN DISGUISE

Q I have always disliked the modern brick porch at the front of my house. However, I can't live without it as it gives me invaluable space for storing boots, jackets, prams and all sorts of other paraphernalia. It is 2.8m (9ft) high, and the floor measures around 1.8 x 1.25m (6 x 4ft). How can I make it look like an attractive feature of the house rather than an ugly box?

Buy some good climbing plants such as passion flower, clematis and climbing rose from your local garden centre. Now dig trenches at the sides of the porch. Fill the trenches with drainage material, such as broken-down rubble, and then pile in a good compost-laden soil. Screw some wooden trellis to the walls and plant four or five climbing plants, each of which will flower at a different time of the year. It's also a good idea to include at least one evergreen. If you can afford it, buy a couple of mature plants that are at least 1m (3ft) tall so that you'll have some instant cover while the other plants have a chance to catch up. By next summer you'll be so impressed that you'll be wondering what you can do about covering up the rest of the house.

WALL DECORATION

Q The brick walls around my back door look dull and uninteresting. How could I brighten them up?

Buy an assortment of galvanized steel containers in different sizes. Fill them with a good potting compost. (First, partly fill the larger containers with gravel or polystyrene balls to avoid using excessive amounts.) Plant fast-growing climbers such as clematis, sweet peas or runner beans. Then construct bamboo wigwams for each container – you will need between five and seven poles for each one. Push a cane into the top 15–25cm (6–10in) of soil in each container, then weave some raffia around each wigwam every 20cm (8in) or so to give the canes more stability. Cover the soil with white stones and place the pots against the walls.

BALL SENSE

Q I am in the process of redecorating the front of my terrace house and would like to give a smart new look to the low garden wall. However, I don't want anything too quirky or something that I will tire of. Do you have any ideas?

You need a simple, stylish idea. I would favour a row of cement spheres mounted along the top of the wall. The first thing you should do is have the wall rendered by a professional (unless you are very adept with a float and trowel) to give it sleek, clean lines. Once this rendering is dry, paint it a pale dove grey, which looks very chic on external masonry and woodwork. You can buy decorative spheres from many garden centres, but a cheaper option is to cast your own inside the halves of a plastic ball. When dry, join them with quick-set cement. Depending on the length of the wall, secure the spheres at between 50cm (20in) and 1m (3ft) intervals using heavy-duty, double-ended screws and plastic plugs, and a good daub of high-strength resin glue. Finally, paint them the same colour as the wall.

TAKE A BREAK

Q I have recently moved house. When I unpacked, I found that several pieces of crockery and glass had been cracked or badly broken. None of it is valuable enough to justify mending, but before I chuck the lot out, is there anything you can suggest I could do with the pieces?

Don't chuck anything away. Broken china can be used to make mosaics. Put all your broken treasures into a large cardboard box and break the lot into pieces with a hammer. You will need fairly small, irregular-shaped pieces (leave cup handles and teapot spouts intact). Tint ordinary tile adhesive or grout with a tube of artists' acrylic colour, and spread a thick layer over a tall, terracotta plant pot, then push the tesserae into it. Keep the bits as close together as you can, and let the grout push up around the sides of each piece to cover sharp edges. The pots look fantastic when planted with tall spiky plants, such as a voodoo lily – so good, in fact, that you'll be looking forward to the next breakage.

BOXES OF DELIGHT

Q I would like to make some window boxes to cheer up the front of our house. There are four large ledges to fill. I don't want to spend much money but I would like something slightly out of the ordinary.

First, find the biggest plastic window box that your ledges will hold. You can then have a lot of fun decorating the sides. My favourite option would be to take handfuls of thin, spindly twigs – ideally, willow or dogwood – cut them to the same height as the box, and then, making sure you have enough twigs to obscure the plastic sides completely, stick them in place with a glue gun. Once the glue has dried, tie a length of raffia horizontally around the middle of the box. Alternatively, many garden centres sell 'log roll' edging (normally used to create borders), which will give a more robustly rustic look and will last longer. Use wire to hold it in place.

CLEVER COVER-UPS

Q Most of the plants in my tiny conservatory are in large plastic flowerpots. How can I make them look smarter?

There's a lot you can do to disguise plastic. If you can find them, long cinnamon sticks look great when tied around the sides of a pot. Glue each stick in place first and then tie a band of raffia around it to make it secure. You can create a similar look with twigs or short lengths of bamboo. Reindeer moss makes another attractive finish, and you can glue this to pots using a glue gun. Another idea that is well worth the effort, even though it is rather time-consuming, would be to stick creamy-coloured, dried haricot beans around the sides of a pot. Strips of foreign newspaper can also look very pretty when you paste them around the sides. Leave a narrow space between one strip and the next, and then give the pot a coat of acrylic varnish when the glue has dried.

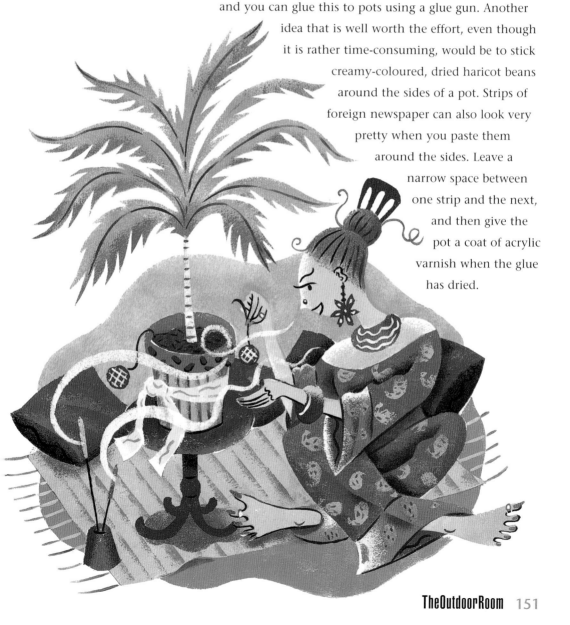

REFLECT ACTION

Q In my new conservatory, the brickwork on what was an external wall is a bit worn. There is also a window in the wall. I don't wish to paint the bricks but would be grateful for any ideas to brighten them up.

I think plants are the solution to your drab brickwork. I'm sure that your local nursery will be able to supply you with a combination of good climbers best suited to the conditions in your conservatory, but personally, being rather impatient, I find that plants usually move a bit too slowly for my liking. I would be tempted to create some instant results while waiting for the plants to grow. An effective plan would be to attach a pair of arch-shaped trellises around two similarly shaped mirrors. This will create a feeling of depth, and the mirrors will also make the conservatory seem larger and brighter.

LIGHT-HEADED

Q I am planning a 40th birthday party for my husband in January. Our house is reached through quite a large garden and I would like to create some stunning light features. Do you have any ideas?

For dramatic effect, put night lights in large, square paper bags – the effect is amazing. There is a small chance that one of the bags will burn, so under no circumstances should this be tried indoors. To stop the bags blowing around, fill the bottoms with plenty of sand and then pop a night light inside. Place the bags in lines along paths and in flowerbeds.

Another idea is to make several cylindrical, perforated metal lanterns. You will need some sheet metal, florists' wire, a hammer, a large nail and some church candles. Each lantern should have a circumference of about 70cm (27in), so have the metal cut to about 75 x 45cm (30 x 17in). Use a pencil to mark 'stitch' holes down either side, about 1cm (⅜in) in from each edge and 2cm (⅜in) apart. Make the holes using the hammer and nail, then continue punching holes randomly over the whole surface to create a perforated look. Roll each piece of metal lengthways, overlapping the edges, and thread the florists' wire through the 'stitch' holes either in cross or regular running stitches. To secure each end, wrap the wire through the outermost two holes a few times and twist off. Push each lantern about 10cm (4in) into the ground, and place a church candle inside each one. Make at least five to plant beneath the trees, and perhaps another five or ten to dot around the garden or along the edge of a path. Then buy or borrow a brazier so that guests can keep warm as they pause to admire your wonderful lighting effects.

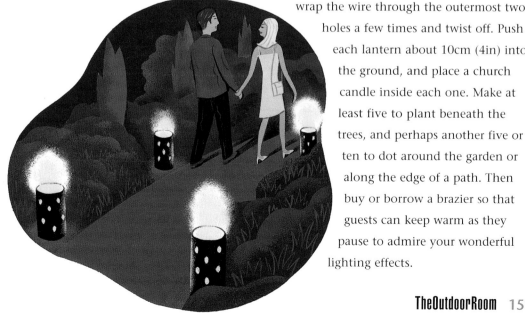

CHIC SHELTER

Q I want a makeshift canopy for our patio. All the ones I have seen in brochures and catalogues would make my house look like an ice-cream shop. Have you any suggestions for a stylish home-made alternative?

Bamboo is very fashionable at the moment and would be perfect for this purpose. Screw some large hooks into the outside wall using a masonry drill bit and plastic plugs. Use these to hold two corners of a wide bamboo panel (available at most garden centres). Again using hooks and 'eyes', secure the outer corners to two vertical 2.5m (8ft) posts made from 7.5cm (3in) square timber. (For a patio that is away from the house, secure the panel to four posts.) Cement these posts into large, wide-bottomed, galvanized buckets, or build wide boxes from plywood to create concrete blocks.

SMALL IS BEAUTIFUL

Q I have a very small patio garden that gets very little light and I want to add colour using pots and furniture. What do you suggest?

Choose one dominant colour, such as a vivid Moroccan blue. Unlike blues at the other end of the colour spectrum, this deep, rich blue has lots of 'warmth' to it and works well in either a minimal, Japanese-style garden or in a more luxurious, leafy setting. Paint terracotta pots, window boxes and troughs blue (emulsion is fine if you seal it with acrylic varnish), and decorate some with small pieces of mirror to create a mosaic effect. Metal garden chairs and a round café-style table will look good, particularly if they have a silvery finish. Fix a sheet of mirror glass on the walls, as this will increase the feeling of space, just as it does when you have mirrors inside.

REFINED PALLET

Q I would like to make a sun lounger for my roof terrace. Do you have any suggestions?

Wooden pallet boards, softened with a large, plump cushion, would offer a seriously chic and inexpensive alternative to a pricey sun lounger from a shop. You will need three pallet boards in all – two to make the base and a third to make a back support. First, sand the boards, then clean them with lots of soap and water. Use wood screws to join two of the pallets for the base. (If the slats overhang the edge, saw them off.) Join the third pallet board using two or three strong hinges, then make a triangular frame that will support the back-rest in the most comfortable position. Finish the whole with one of the many exterior wood paints that are available, or use a satin-finish, solvent-based paint in a colour of your choice. Finally, buy a piece of foam that has been cut to the same size as the bed and cover it in calico.

FAST FOOD

Q Can you suggest a way in which I could construct an efficient, good-looking barbecue?

Build two walls of bricks to a workable height and lay a large paving slab on top of them. Aim for this base to be about 50cm (20in) square. Build another course of bricks on top of the slab to create a shallow pit for the charcoal. This should be narrower than the base. I would then borrow a rack from your cooker and place this on the top of the uppermost bricks. Just add fire when you are in the mood for some outdoor cooking.

BENCH MARK

Q Do you have any good ideas for making a plain, rustic garden bench?

To me, the combination of stone and wood is a marriage made in heaven. For a sensational-looking bench, invest in a slab of natural rock measuring about 1.6m x 50cm (5ft x 20in), and support it on two rectangular blocks of timber. Use hardwood or pressure-treated timber. (If you choose a softwood, make sure it has been treated with an exterior preservative.) Whichever you choose, each block should be around 50cm (20in) wide, 50cm (20in) high and 20cm (8in) deep. Fix the stone slab to the timber blocks with quick-setting cement. Finally, all you need is a foam cushion to cover the seat and two bolsters for the ends. Cover all three pieces with cream canvas or natural linen to create the bench of your dreams.

LITTER OUT

Q **Rubbish from the road blows in through the iron railings of my front garden. Can you think of an attractive way to keep it out without putting up a low fence?**

The answer to the rubbish problem lies in a good planting scheme. Buy enough rectangular, galvanized steel planters to run along the length of the railings. Prepare the containers *in situ*, ensuring there is good drainage. (Place crocks and gravel in the bases before filling with soil-based compost.) Plant tall screening trees such as silvery cypress, and underplant these with box trees that will grow into a thick hedge as well as catch any stray crisp packets.

WITHDRAWN

AUTHOR'S ACKNOWLEDGEMENTS

My thanks to: Emma Soames, Giles Kime and Sara Stewart Smith at the Saturday *Telegraph magazine* who initiated the *Trade Secrets* column; all loyal magazine readers, particularly those who have taken the time to write to me with their home décor problems and so provide the fuel for the column; illustrator Mark McConnell, who cleverly translated my words into witty pictures, which have kept me amused on many a Saturday morning; and, finally, the masterful Helen Chislett for compiling this book, and Araminta Whitley for making it happen in the first place.